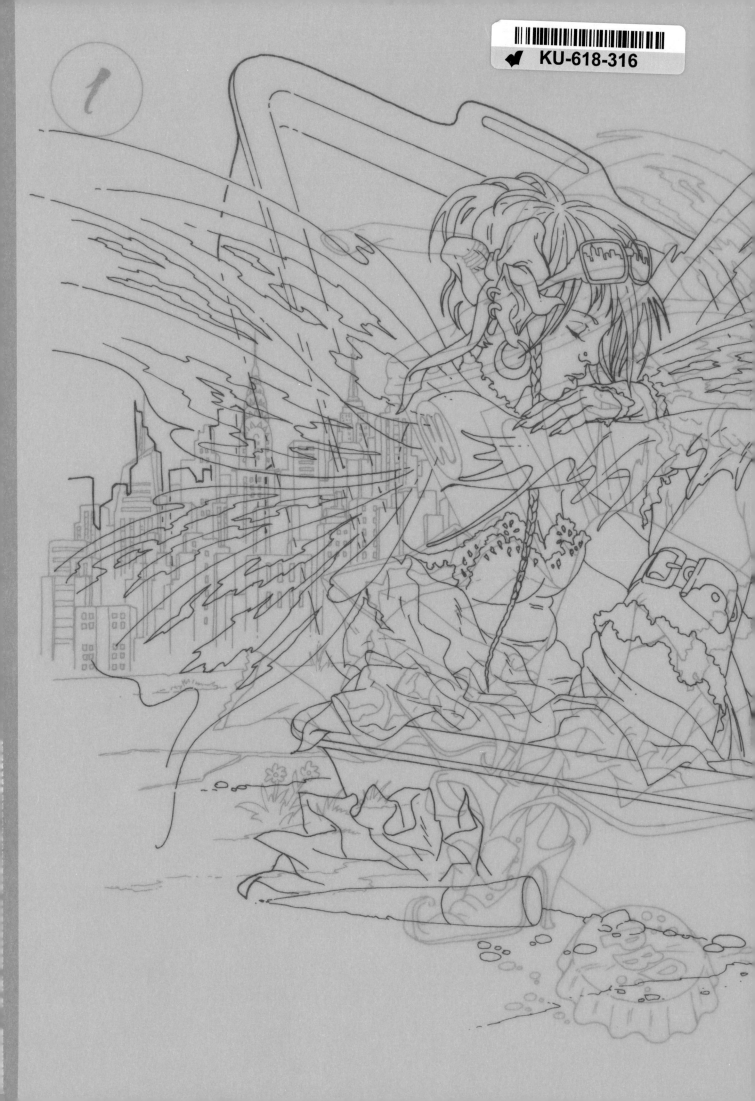

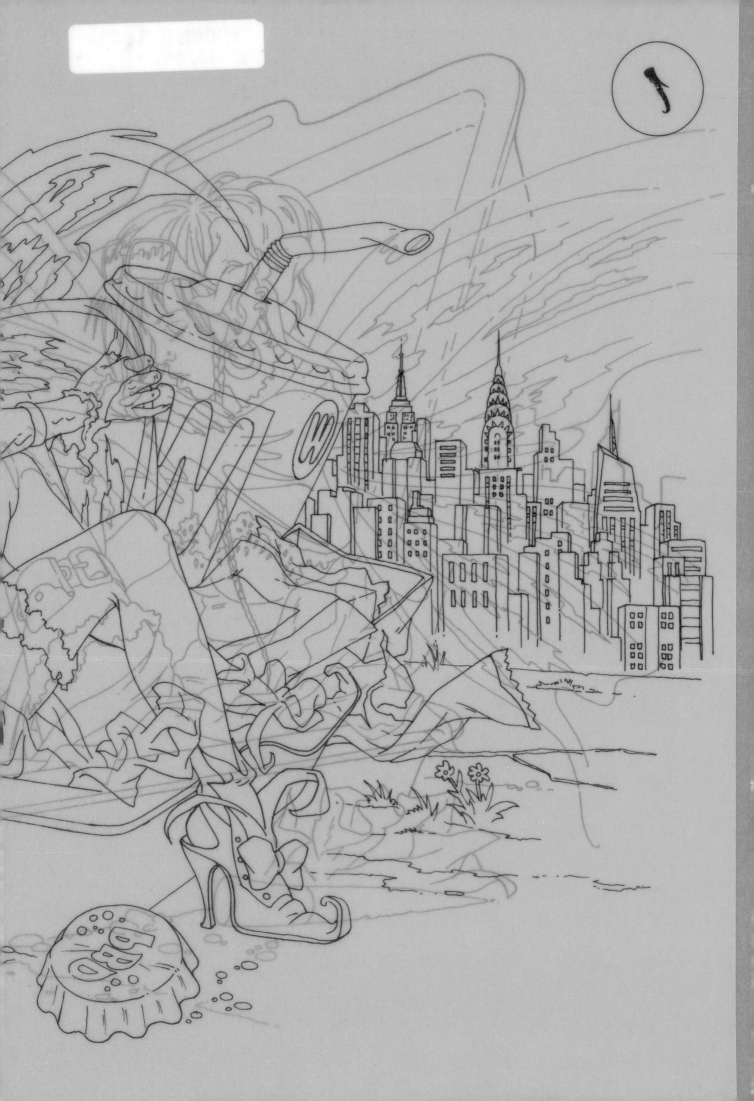

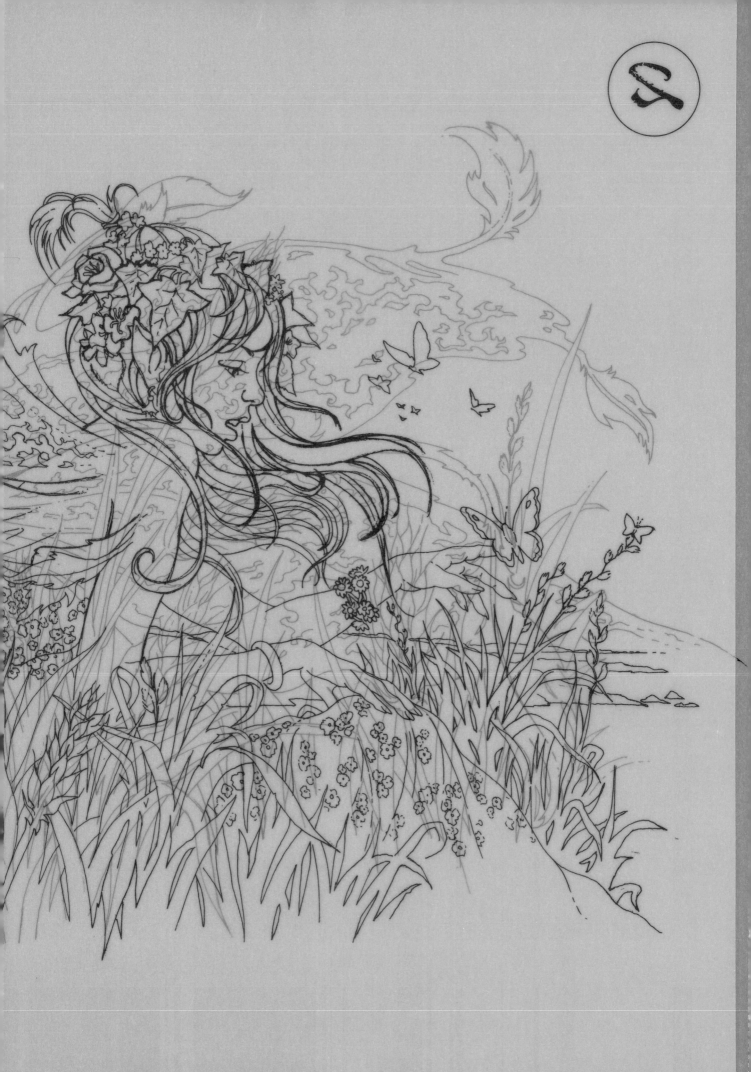

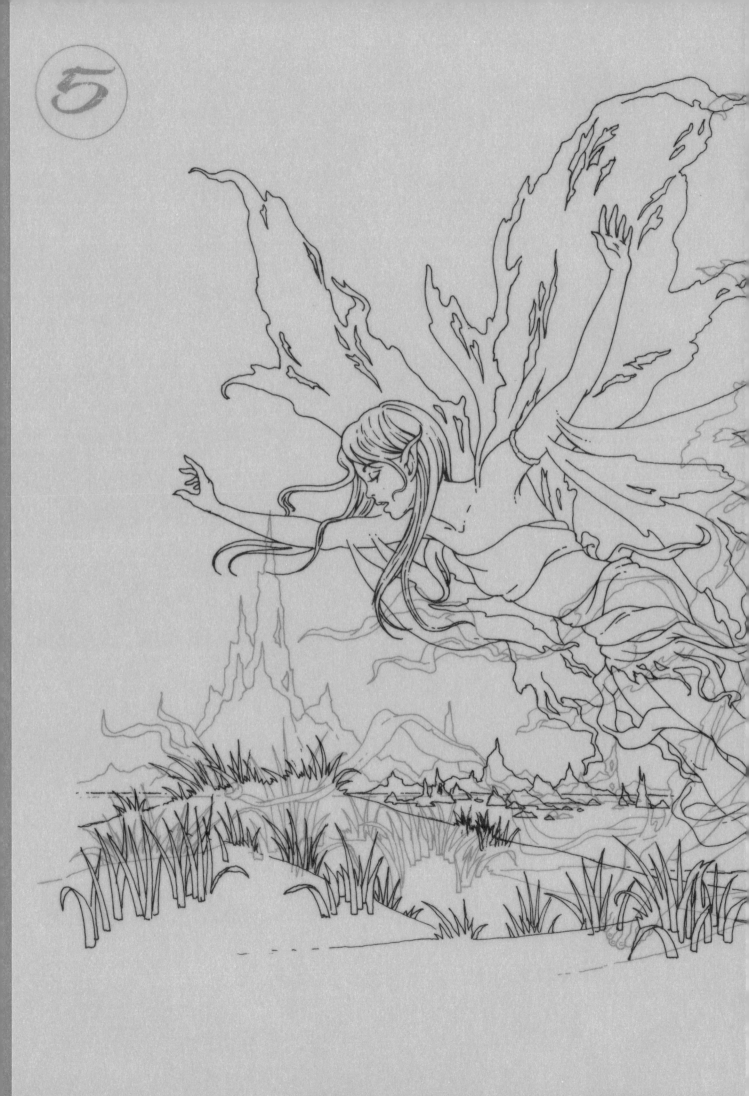

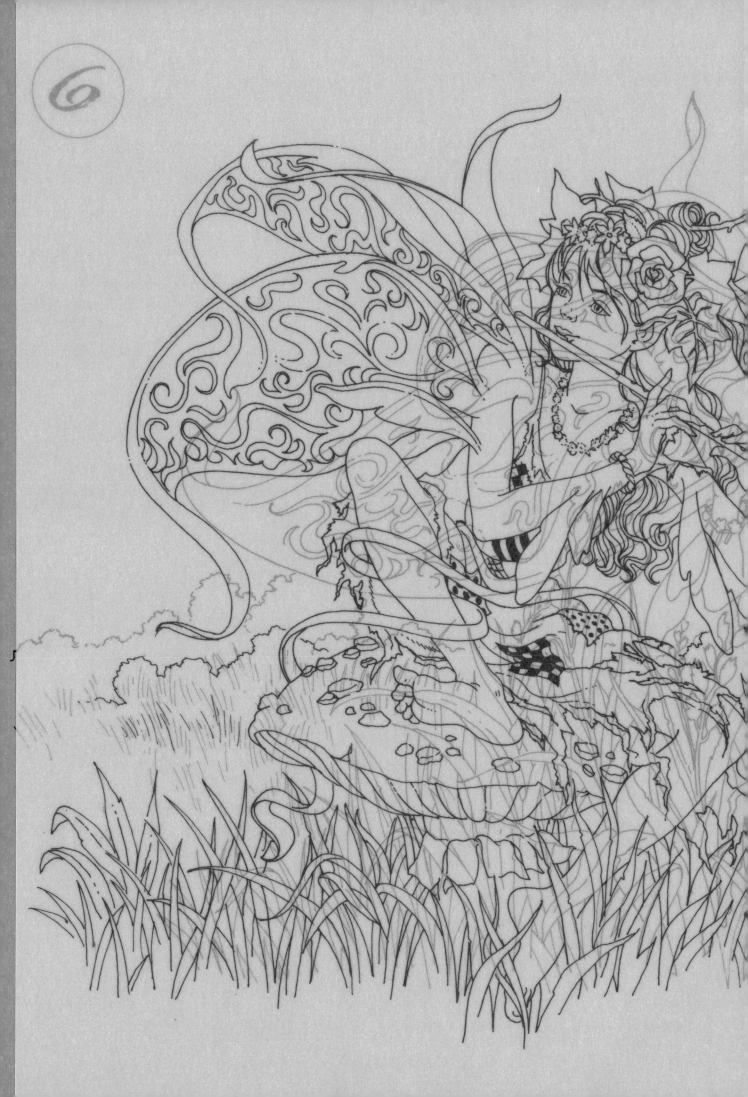

READY TO PAINT

FAIRIES

PAUL BRYN DAVIES

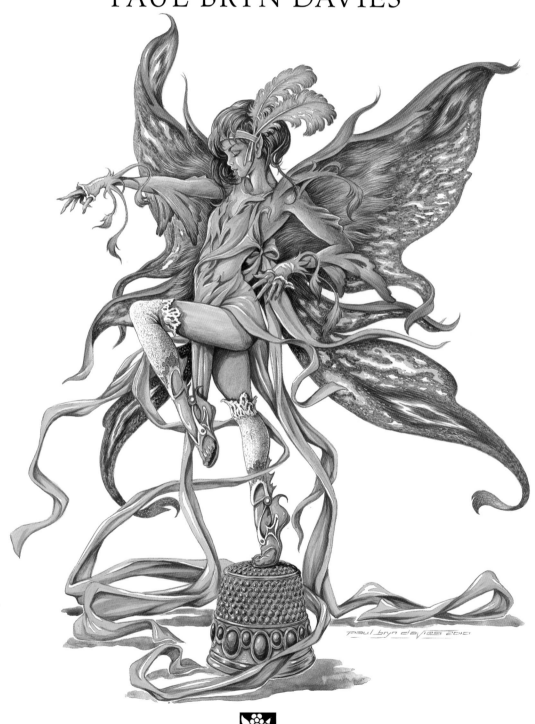

SEARCH PRESS

First published in Great Britain 2011

Search Press Limited
Wellwood, North Farm Road,
Tunbridge Wells, Kent TN2 3DR

Text copyright © Paul Bryn Davies 2011

Photographs by Debbie Patterson at Search Press Studios

Photographs and design copyright © Search Press Ltd 2011

ISBN: 978-1-84448-639-7

The Publishers and author can accept no responsibility for any consequences arising from the information, advice or instructions given in this publication.

Suppliers
If you have any difficulty obtaining any of the materials and equipment mentioned in this book, please visit the search press website: www.searchpress.com

Publishers' notes
All the step-by-step photographs in this book feature the author, Paul Bryn Davies, demonstrating his watercolour painting techniques. No models have been used.

Please note: when removing the perforated sheets of tracing paper from the book, score them first, then carefully pull out each sheet.

Share your Ready to Paint artworks with the world. Simply go to the 'Ready to Paint' page on Facebook and upload your images.

DEDICATION

This book is dedicated to Jules, my wife (Fairy Queen), and Eileen Lily, my Mum (Fairy Godmother), who were both very unwell around the time the paintings in this book were produced. I send them my love and good wishes for their recovery and the mending of their broken wings.

ACKNOWLEDGEMENTS

First, a thank you to Roz Dace at Search Press for her constant enthusiasm for these fantasy projects. Thank you also to Katie Sparkes, my editor, and Debbie Patterson, my photographer, for their company, good humour and professionalism during the arduous but enjoyable step-by-step photo sessions in the cold month of November. Thanks also to all at Search Press. From the top to the bottom they are a good-natured bunch of human beings. Long live the independents.

Front cover
The Dune Glider
Watercolour and gouache step by step (see page 42).

Page 1
Thimble Lena
This tiny poser is painted in watercolour and gouache on 140gsm (70lb) HP (smooth) paper. This is the perfect finish for a painting requiring detail. As with many of the paintings in this book I have limited my palette, mainly to warm colours. These are: watercolour – raw sienna, burnt sienna, Chinese white, cadmium red deep, perylene maroon, gamboge yellow and ivory black; gouache – gold ochre, permanent white and burnt umber.

Page 3
Josie and the Ladybirds
This is the only painting in the book based on a photograph. The picture was a random shot of my daughter, Josie-Beth, in a pensive mood, walking a dog. This painting, for that reason, has a more realistic feel than many of the projects in the book. It was painted on 140gsm (70lb) HP (smooth) paper in watercolour with gouache highlights. For the background I have used cobalt green, sap green and gamboge yellow; the leaves are painted using sap green, Prussian blue and gamboge yellow; and for the wings, dress and ladybirds I have used mauve, ivory black, dioxazine violet, cadmium red deep, yellow ochre and burnt sienna.

Printed in China

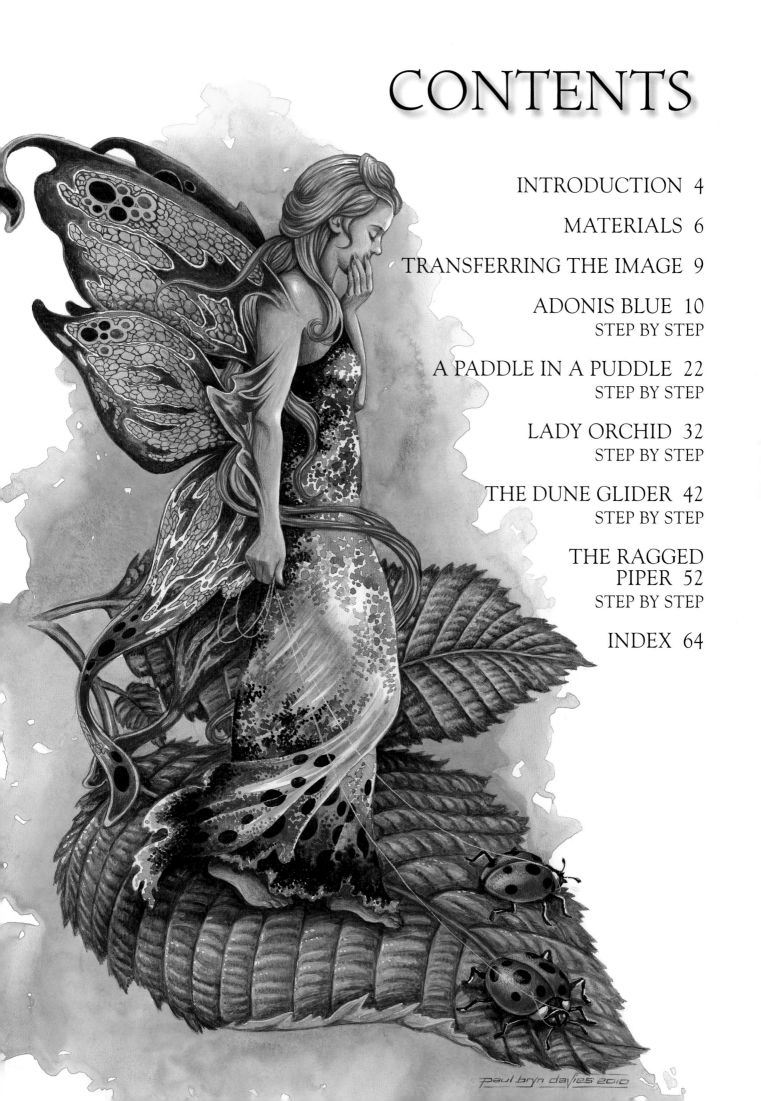

CONTENTS

paul bryn davies 2010

INTRODUCTION

When the commissioning editor at Search Press asked me if I was interested in producing another fairies title there was no doubt in my mind what the answer would be. My work as an artist is largely fantasy based and fairies are probably my favourite subject. As with my previous Search Press title *Fairies in Watercolour*, I have tried to include a varied selection of these tiny, ethereal beings in both rural and urban environments. When creating a fairy composition with an urban backdrop, the design of the clothing and the overall style or 'attitude' of the character should be influenced by her setting. The same should be said of a fairy within a rural environment.

The main difference between this book and my previous one, apart from there being more projects, is the inclusion of the tracings. There is no apology for the lack of instructions on how to draw the fairies, because all the projects are supplied as tracings. Many artists find the drawing stage quite difficult, particularly when it comes to drawing the human figure. The supplied tracings are taken directly from my conceptual pencil drawings and should help you with the initial stages of the painting. This leaves you a lot more time to spend on the colour work and improving your watercolour technique.

Should you wish to create your own compositions, the easiest way to start is by using photographic reference and adding the wings, ears, clothing, etc. to your trace. Mail-order catalogues or photographs of family members or friends can be useful for this and will help you create your own original drawings. The one painting in this book where I have taken this approach is *Josie and the Ladybirds* on page 3. A method of drawing fairies without the use of photographic reference material is covered in my book *How to Draw Fairies in Simple Steps,* also published by Search Press.

There is a reasonable amount of detail in each of the projects and this is something I see as the core of most fantasy paintings. The detail on the tracings could be reduced or enhanced according to your taste or level of painting skill. Personally, it is the detail within a painting that I am most attracted to. The investment of time is essential to the creation of a fantasy painting and what better place to get lost than in your own vivid imagination!

Take a look out of the window – is it a grey, miserable day? If so, why not dust off that old watercolour set (or better still, treat yourself to a new one), open your wings, and fly with the fairies.

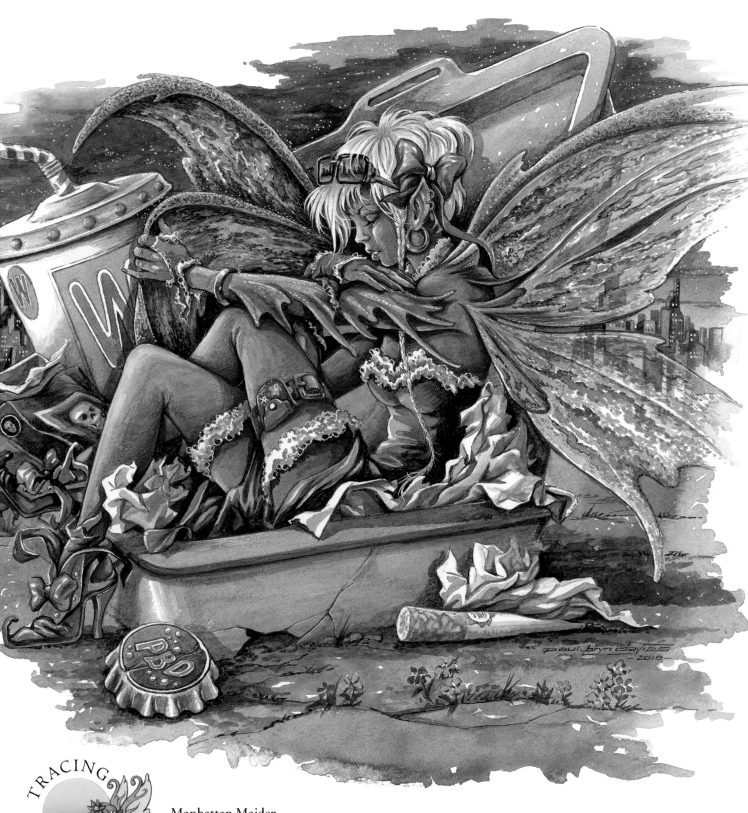

Manhattan Maiden

The inspiration for this painting came from a recent visit to New York. I often find urban environments interesting to use in some of my fairy paintings. This painting gave me the opportunity to pay homage to this amazing and vibrant city in this introduction piece. I have used 425gsm (200lb) NOT watercolour paper. The watercolours used are Prussian blue, intense blue, dioxazine violet, cadmium red, alizarin crimson, mauve, Payne's gray, raw sienna, gamboge yellow, burnt sienna, burnt umber and ivory black; permanent white gouache was also used.

MATERIALS

The range of materials available to the artist can be daunting,
and their quality varies depending on how much you can afford to pay.
Here I shall offer you some simple guidance to help you choose the right
materials to begin your journey.

PAINTS

Watercolours are available mainly in two formats: pans and tubes; and in two
levels of quality: artists' or professional quality and students' quality. I recommend
tube paints, which can be purchased as a beginner's set, and suggest starting with
around ten to twelve colours including the primaries. If your budget can stretch
to artists' quality colours, these are ideal as they offer richer pigments and tend
to be more lightfast. Artists' quality paints are a lot more expensive than students'
quality, but they tend to go further. The projects in this book have been created
using equal numbers of both. You should also add a tube of white gouache and
possibly titanium white (an opaque watercolour) to your collection. Watercolour
has a translucent quality whereas gouache offers a great deal of opacity, which
makes it ideal for highlighting.

*A selection of artists' and students'
quality watercolour paints in tube form.*

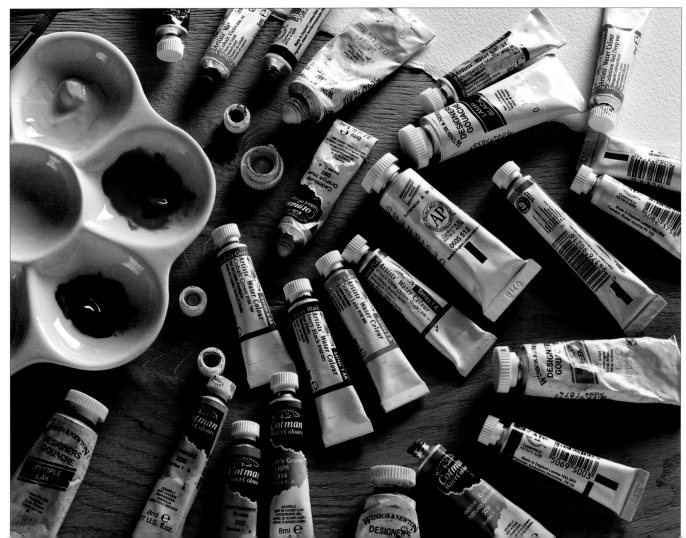

BRUSHES

There is a bewildering range of brushes available. Watercolour brushes are available as pure sable, a sable/synthetic mix and plain synthetic. Pure sable brushes are generally considered the best quality, but are expensive. They carry plenty of paint, are easy to control and keep a fine point, so many artists prefer these. Sable/synthetic mix brushes are more than adequate, however, and I would recommend using these as a cheaper alternative to pure sable. In general, use fine brushes, numbers 0, 1, 2 and 3, for detailing, and numbers 5, 6, and 7 for the broader colour washes you will need for skies and basic backgrounds. Synthetic brushes are adequate for larger wash areas.

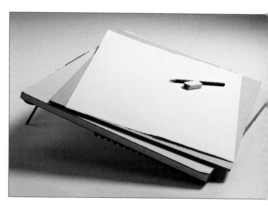

From top to bottom: no. 7 synthetic round, no. 6 synthetic round, no. 1 sable, no. 2 sable and no. 0 sable.

BOARD

You need to work on a smooth, stable surface that you can tilt, so for the projects in this book I would recommend you use a drawing board. Purpose-made drawing boards, like the one shown in the picture opposite, are ideal, but they are expensive. A cheaper alternative is a piece of MDF (medium-density fibreboard) measuring around 650 x 480mm (25½ x 19in), or a piece of melamine-faced chipboard, which is what I use. You can buy both of these from your local DIY store – they may even cut them to size for you.

PAPER

This is not an area in which to cut corners. Watercolour paper is available in various finishes from smooth to rough and in various weights. Cockling or buckling of the paper can be avoided by using a heavier grade paper when applying large areas of colour wash. The heaviest grade paper is 640gsm (300lb) and is more like card than paper. The minimum weight I would recommend when getting started would be 300gsm (140lb). The finishes or surface textures of watercolour paper are: HP, which stands for hot pressed, and is very smooth; NOT or cold pressed (semi-rough); and rough, which is heavily textured. All the projects in this book were produced on 425gsm (200lb) semi-rough paper. *Manhattan Maiden* on page 5 was also painted on this grade of paper; *Thimble Lena* (page 1) and *Josie and the Ladybirds* (page 3) were both painted on 140gsm (70lb) HP (smooth) paper.

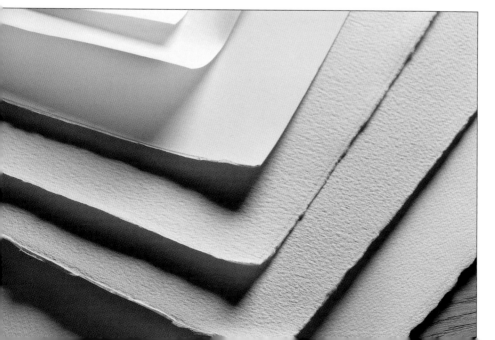

A professional drawing board and a piece of MDF, both suitable to use as boards on which to support your watercolour painting.

A selection of watercolour papers of various textures and weights.

OTHER ITEMS

Pencils and sharpener You will need a soft 2B or B pencil to trace over the back of the image before transferring it to your watercolour paper. Keep a good point on your pencil using the sharpener.

Eraser Use a soft-grade or putty eraser (a harder one can damage the surface of your paper) in the unlikely event that you make a mistake!

Kitchen paper This is for wiping off excess paint from your brushes, mopping up spillages and lifting out or softening colour.

Masking tape Used to secure your paper to the drawing surface or board.

Burnisher A purpose-made tool for transferring your tracing to a new sheet of paper. Alternatively, use a ballpoint-pen cap or the back of a spoon instead.

Hairdryer A hairdryer can be used to speed up the drying process, and helps prevent cockling, though it should be used with caution; over-heating a painting that has masking fluid applied to it can cause the masking fluid to adhere to the paper and be difficult to remove.

Palette Traditional china palettes make colour mixing easier, as you are looking at your colours on a white surface. Plastic palettes can also be used, or old white china such as a plate or saucer.

Water pot You can buy plastic, spill-proof pots for your water, which are inexpensive and practical. An old jam jar can be used as an alternative.

Masking fluid Used for creating special effects and protecting previously painted detail.

Ruler Though not strictly necessary for the projects in this book, a ruler can be useful for maintaining straight edges and positioning your drawing centrally on the watercolour paper.

Light box Though expensive, a light box can make transferring the image easier.

A water pot, masking fluid, masking tape, palettes, kitchen paper, light box, ruler, sharpener, pencils, fine ballpoint pen, burnishers and eraser.

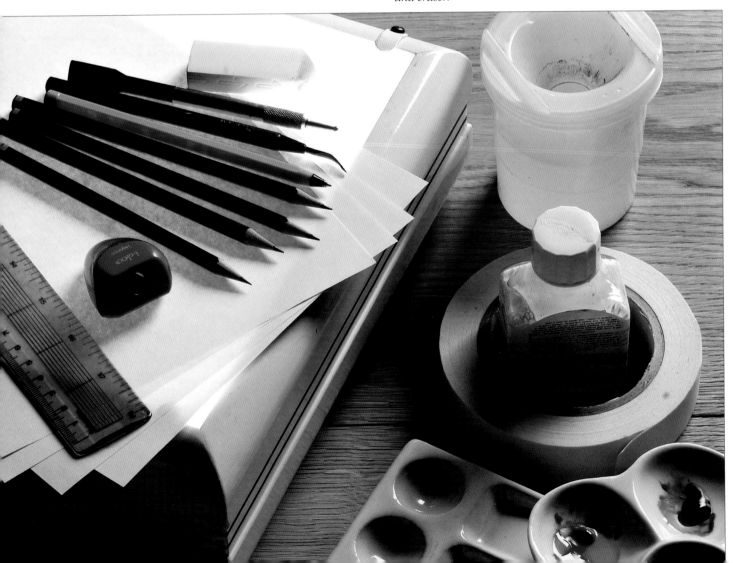

TRANSFERRING
THE IMAGE

It is very easy to pull out a tracing from the front of this book and transfer the image on to watercolour paper. You should be able to reuse each tracing several times if you want to create different versions of the scene.

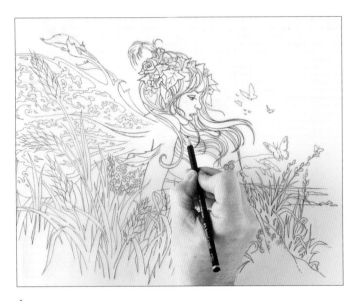

1 Run your pencil carefully over the reverse of the tracing with a soft pencil such as a B or 2B.

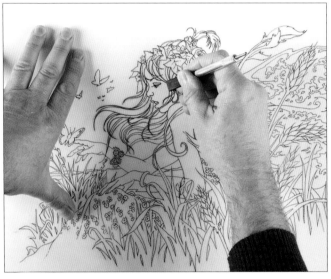

2 Turn the tracing right side up and place it face up on your watercolour paper. Tape it down using masking tape. Using a burnishing tool, the back of a spoon or a ballpoint-pen cap, firmly trace over all the lines.

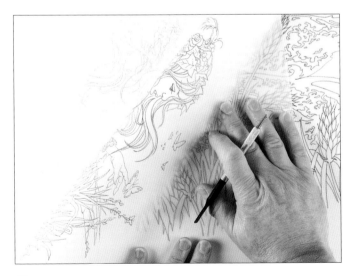

3 Lift up the tracing and you will see the drawing beginning to appear on the watercolour paper. Do not worry if it looks faint; if it is too strong, the graphite can smudge during the painting process and look untidy. Once the pencil marks are transferred, remove the tracing.

4 Paint carefully over the outline using a mix of burnt umber and burnt sienna, mixed 1 part colour with 2 parts water, and a no. 0 or no. 1 sable brush. Rest your hand on a sheet of spare paper to avoid smudging the drawing as you work.

Adonis Blue

This was one of the first paintings created for this book. I wanted to include a piece featuring butterflies and while searching out some references, found the Adonis Blue. This not only gave me what I considered to be a great title for the painting but also the inspiration for the colour scheme.

You will need

Watercolour paper: 425gsm (200lb) rough finish, 56 x 38cm (22 x 15in)

Masking fluid

Watercolours: burnt umber, burnt sienna, Chinese white, yellow ochre, mauve, phthalo blue, ultramarine, raw sienna, sap green, gamboge yellow, viridian, Winsor green, cobalt blue, gold ochre, alizarin crimson, magnesium brown, ivory black, dioxazine violet

Gouache: burnt umber, permanent white

Brushes: nos 0, 1, 2, 3 and 4 pointed round sable; no. 6 sable or sable/synthetic mix; an old no. 2 or no. 3 brush for the masking fluid application

1 Trace off the image and paint over the outline following the instructions on page 9. Rest your hand on a piece of scrap paper and apply masking fluid to the finer detail around the edge of the painting. Use an old no. 2 sable brush. This will prevent the wash of colour applied to the sky in step 2 from running into the main image. Allow the masking fluid to dry.

Tip
If applying masking fluid to a large area, rinse out the brush halfway through to prevent clogging. Wipe off any stray pieces of masking fluid before it dries.

2 Lay the sky wash using a no. 6 sable round brush and a watery mix of 5 parts phthalo blue and 1 part mauve. Loosely run the colour into the sky area, starting on the left, working it carefully around the detailing. Leave a few tiny white patches and stop just short of the horizon. Wash out the brush and soften the edges.

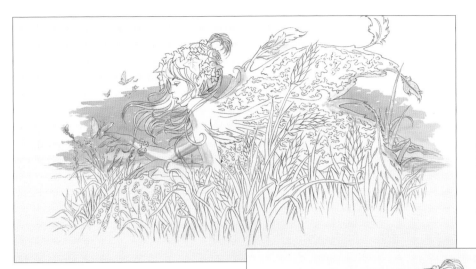

3 Continue the sky on the rest of the painting. Allow the paint to dry and then rub off the masking fluid using either your finger or a piece of kitchen paper wrapped around your finger.

Tip
Always try to work from the back of a painting towards the front.

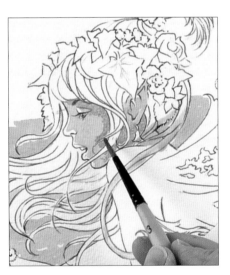

4 Apply more masking fluid to the fairy's eye and to the corn where it covers the fairy's wings and body. (The corn will be one of the last areas to be painted.) Allow the masking fluid to dry.

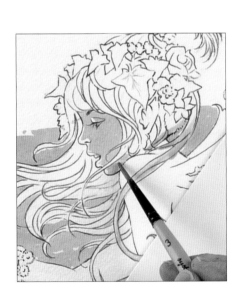

5 Allow to dry. Using clean water, mix 4 parts Chinese white and 1 part burnt sienna with a tiny touch of yellow ochre for the flesh tones. Test out the colour on a piece of scrap paper before applying it to your painting. Also mix some burnt umber ready to drop into the darker areas. With a no. 3 round brush, touch in the colour on the face, leaving a little white around the front edge of the face and on the eyelid.

6 Continue putting in the skin tone, leaving small patches of white here and there. While the paint is still wet, add a little burnt umber to the mix and drop it in around the side of the face.

7 Rinse out the brush and quickly soften the edges to blend in the darker tone.

Tip
Locate your light source before you start painting – here it is coming from the top left.

8 Returning to the flesh tone, put in the shoulder and arm, spreading some of the paint into the base of the wing and fading it out.

9 Keep the brush fairly well loaded and work down the arm and body, and into the second wing. Leave a highlight on the top of each finger. These can be softened in later.

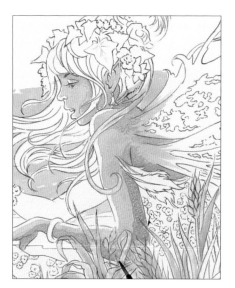

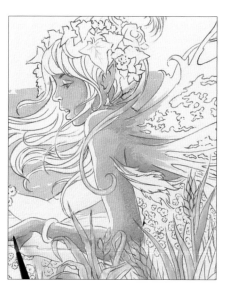

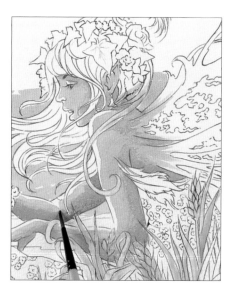

10 Using wet-in-wet, use the flesh colour and burnt umber mix to make the darker tones and put these into the shaded areas, starting at the shoulders and back and taking the colour down the back of the upper arm and the underside of the forearm and hand.

11 Soften the edges with a clean, damp brush and allow to dry.

Tip
Do not use too much water to soften the edges otherwise you will lift out the paint.

12 Repeat the same procedure on the other arm, making the shadows slightly deeper than on the foreground arm.

13 Make two fairly watery mixes – one of ultramarine blue and one of mauve. Beginning with the upper wing and keeping within the drawn shapes, run in a little of the blue and then, immediately afterwards, some mauve, allowing the two to bleed into each other.

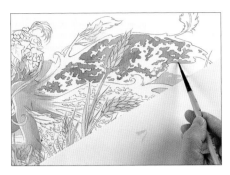

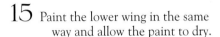

14 Continue swapping from one mix to the other to complete all the shapes on the upper wing.

15 Paint the lower wing in the same way and allow the paint to dry.

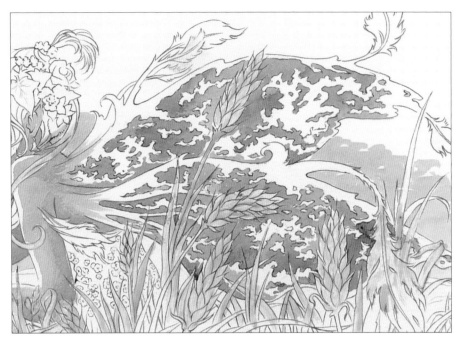

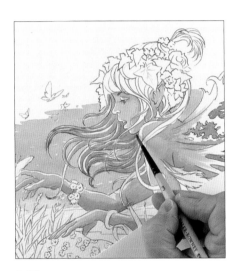

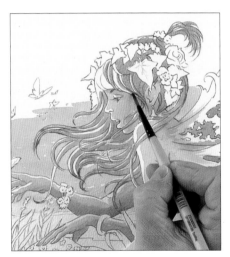

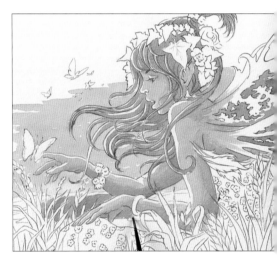

16 Remove all the masking fluid and paint in the lower sections of the fairy's hair. Use a no. 3 round brush and a strong mix of raw sienna, mixed 3 parts water to 1 part colour. Paint in the hair carefully, leaving some white highlights. Deepen the colour around the mouth and chin and leave fewer highlights in this area.

17 Continue up into the top part of the fairy's hair, painting carefully around the leaves and flower adorning her head. Deepen the colour in the darker recesses as before.

18 Mix 1 part sap green with 1 part gamboge yellow and add 5 parts water to make a watery green mix. With a no. 2 round brush, start to put some green into the background. Paint carefully around the stems of corn and the fairy's hand and arms in the foreground. Do not take the colour right up to the sky.

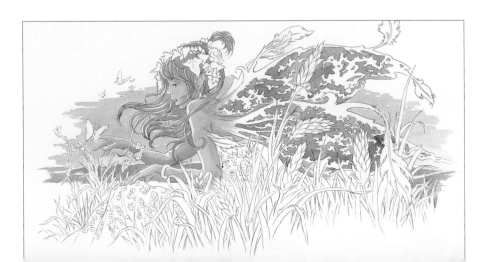

19 Fade the colour out on the left, and then repeat on the right-hand side of the picture.

13

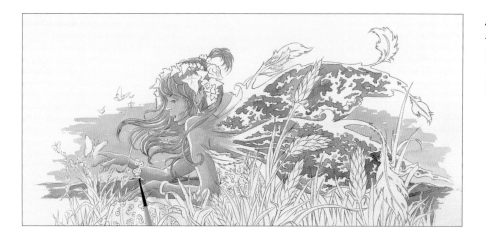

20 Allow the green to dry. Add a little viridian and a little phthalo blue to the green mix, and run some of the darker colour into the background to create hedgerows.

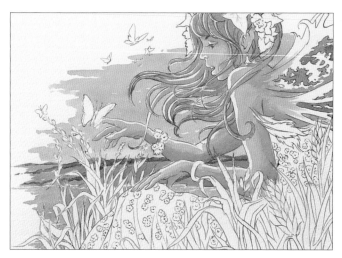

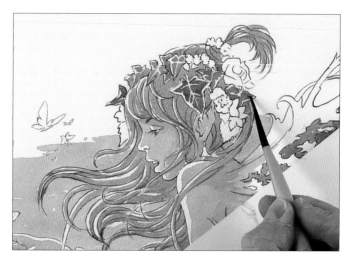

21 Put in the water on the left-hand side of the painting using the same colour as the sky with a little sap green added to it. Use a no. 2 round brush and run the colour carefully around the corn, stopping just short of the green fields in the background. Leave small patches of white here and there where the sunlight catches the water.

22 Continuing with the same brush, put in the ivy leaves in the fairy's hair, leaving the edges and the veins white. Use the same green mix that you used for the hedgerows (see step 20).

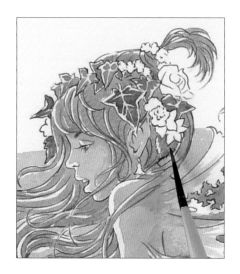

23 For the rest of the leaves in the fairy's hair, use a 1 : 1 mix of Winsor green and gamboge yellow. Again, leave a narrow white edge.

24 Using a mix of 3 parts water to 1 part cobalt blue and a well-loaded brush, start to run colour around the flowers on the fairy's dress. Use the no. 2 brush. Leave a broad area of white around the front of the dress and on the top edges of the folds where the highlights will fall.

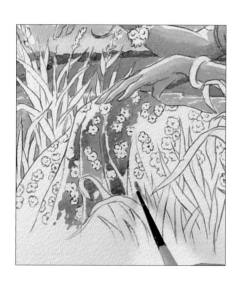

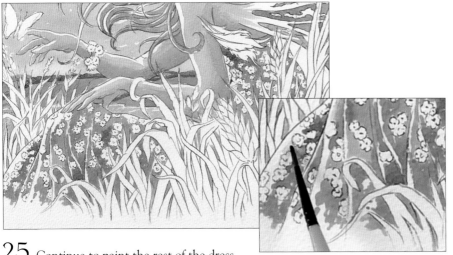

25 Continue to paint the rest of the dress. Do not finish the lower edge too neatly. Work from left to right and paint carefully around the corn. Soften the edges with clean water, retaining the white highlights on the front of the dress and on the folds.

26 Using a no. 4 pointed round, start to paint the corn. Make a mix of 3 parts gold ochre and 1 part Chinese white, watered down with 5 parts water. Leave white highlights on the sides of the stems and the grains that are facing the light.

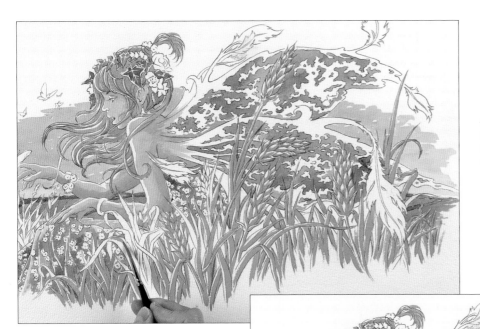

27 Continue to paint the ears, stems and leaves of corn, in any order you wish, leaving white highlights.

28 Once all of the corn has been painted, make a mix of 6 parts gamboge yellow, 1 part Chinese white and 2 parts gold ochre, and mix this with 6 parts water to make a pale yellow. Lay this colour loosely in between the stems and leaves, leaving some tiny white highlights here and there. Be careful not to paint over the white areas on the corn, and leave a fairly loose edge along the bottom. Go over some parts of the corn using the same mix, retaining the original highlights.

29 Mix 1 part ultramarine blue with 4 parts water and use a no. 3 round brush to touch in the tip of the large feather on the lower wing. Take the colour down the side of the main vein.

30 Further down the feather, blend in some mauve, mixed in the ratio of 2 parts water to 1 part colour. Use a fairly dry brush and merge the two colours seamlessly using the brushstrokes rather than wet-in-wet.

31 Again, take the colour down the sides of the main vein.

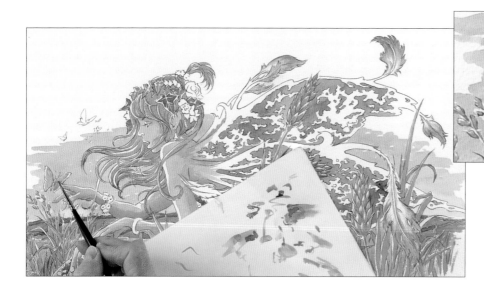

32 Paint all of the feathers in the same way, and then change to the no. 2 round, mix 1 part Chinese white with 2 parts phthalo blue and put in the main butterfly, leaving a thin white edge around the wings.

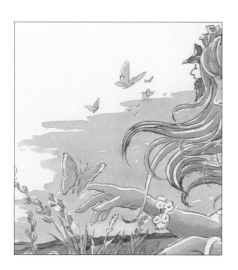

33 Touch in all of the butterflies – no detail is needed for these.

34 With the no. 2 round, put in the flowers in the fairy's hair using a mix of 1 part alizarin crimson and 2 parts water. Leave white edges to the rose petals where they face the light, and tiny white centres in the smaller flowers.

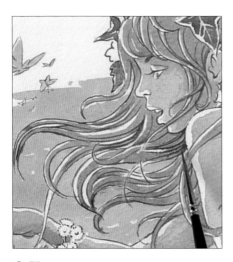

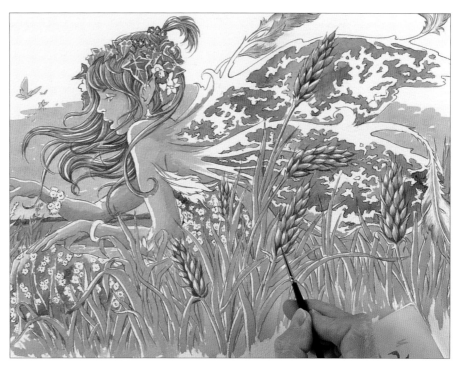

35 Mix 2 parts magnesium brown with 1 part burnt umber gouache to make a denser tone for the hair. Stroke it on using a no. 0 sable brush, following the curve of the hair. Place it where a darker tone is needed, for example where the locks of hair overlap, under the fairy's chin and under the leaves in her hair, to give the hair more definition.

36 Complete the hair. Add a little more burnt umber gouache to the mix to strengthen the colour and place a little of the stronger colour at the base of each grain of corn.

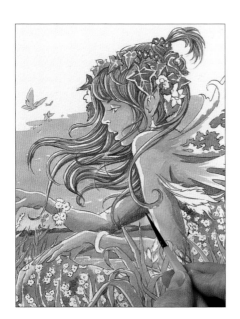

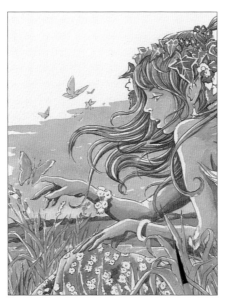

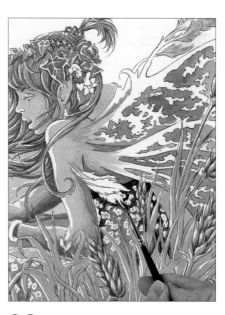

37 With the no. 2 brush and a little burnt umber, darken the areas of flesh tone that are in shade – under the wings, on the arms and between the wings on the fairy's back.

38 Create a strong shadow under the flower bracelet and on the undersides of the hands. This gives an indication of strong sunlight. Rinse out the brush and soften in the shadows.

39 Darken the shaded areas of the dress to give it form. Use a mix of 2 parts ultramarine blue and 1 part ivory black and a no. 1 brush. Drop in the colour under the fairy's arms and down her back, painting carefully around the stems of corn and the feather.

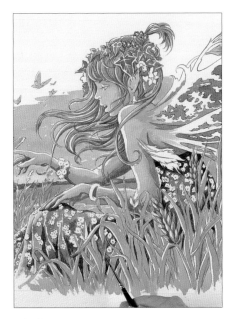

40 Continue down into the lower parts of the dress and the folds, and under the fingers of the fairy's hand where it is resting on her knee.

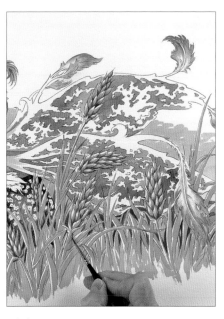

41 Mix 4 parts magnesium brown and 1 part dioxazine violet to make a deep brown and put it into the deepest shadows within the corn to add depth.

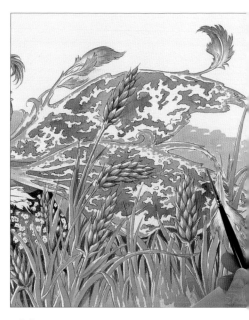

42 Lay a yellow mix of gamboge yellow and a little gold ochre loosely around the edges of the wings, taking the colour part of the way along one or two of the main veins.

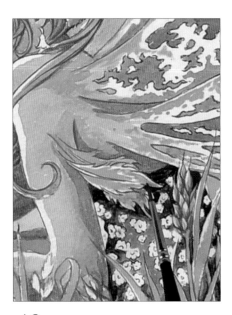

43 Use the same colour on the tiny wing attached to the back of the fairy's arm. While it is still wet, sketch in a little mauve, mixed with plenty of water, at the outer edges.

44 With a no. 1 brush, put a little of the watered-down mauve on the fairy's eyelid. Colour the iris with a touch of phthalo blue.

45 Use the same brush, fairly dry, to paint in the lips using a mix of alizarin crimson and Chinese white. Leave a white highlight.

46 Using the same colour, paint the flower bracelet on the fairy's right wrist, leaving little white highlights on the top edge and in the centre of each flower, and the bangle on her left wrist, again leaving a highlight.

47 Complete the red flowers in the fairy's hair (leave the centres white), then paint the yellow flowers using gamboge yellow.

48 Make a mix of 1 part dioxazine violet and 1 part burnt sienna and put in a few sharper shadows under the bangles and fingers, and under the butterfly on the fairy's right hand. Continue with the same colour to add depth to the deepest recesses of the hair, to darken the areas immediately below the arms and wings and to define the fingernails.

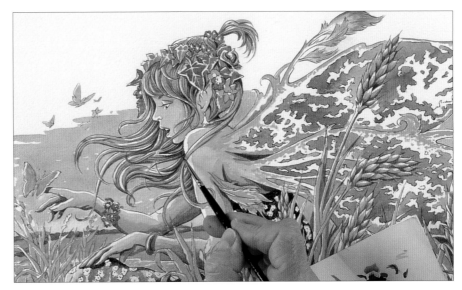

49 Make a strong mix of alizarin crimson and spot in the flowers on the dress.

50 With a no. 0 brush and ivory black, sketch in the body of the butterfly, the antennae and the pattern on the sides of the wings.

Adonis Blue

With a no. 1 sable brush, I used dioxazine violet and burnt umber to further bolden the deeper recesses and shadow areas and define the hair in more detail, and a creamy mix of permanent white gouache to add further highlights. I enhanced the ivy in the fairy's hair with a mixture of viridian and cobalt blue and added extra veins using permanent white gouache. I softened the highlights on the skin with clean water using a no. 4 pointed round brush and deepened the shadow areas where necessary with burnt umber and a little dioxazine violet. Where the wings overlap, I have intensified the blues and mauves to distinguish one layer from another. The gold on the upper edges of the wings has been enhanced with a mixture of gamboge yellow and mauve, and I have added detail to the blues on the wing feathers using ultramarine blue applied with a no. 1 sable brush. In general, I have strengthened the deeper recesses within the corn using a mix of gold ochre, burnt umber and dioxazine violet. Finally, I added further detail and extra highlights to the ears of corn using permanent white gouache.

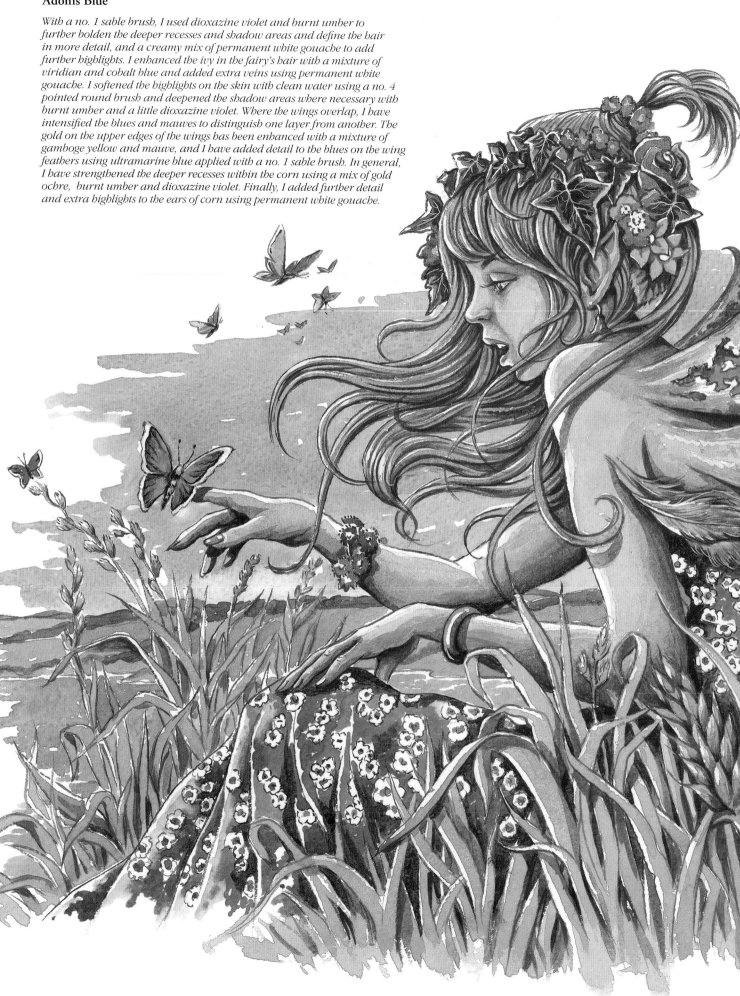

A Paddle in a Puddle

I often like to include a 'prop' in some of my fairy compositions as it helps give the character scale. In this case I've used a fallen leaf as a boat for the fairy to row on the puddle. The fallen leaf also dictated the autumnal colour scheme.

You will need

Watercolour paper: 425gsm (200lb) rough finish, 56 x 38cm (22 x 15in)

Masking fluid

Watercolours: raw sienna, Indian red, Chinese white, burnt sienna, light red, alizarin crimson, yellow ochre, burnt umber, cadmium orange, gamboge yellow, sap green, dioxazine violet, Hooker's green light, gold ochre, Payne's gray, cadmium red deep, phthalo green

Gouache: gold ochre, permanent white

Brushes: nos 0, 1, 2, 3 and 4 pointed round sable; no. 6 round; no. 10 sable synthetic flat; an old no. 2 or no. 3 brush for the masking fluid application

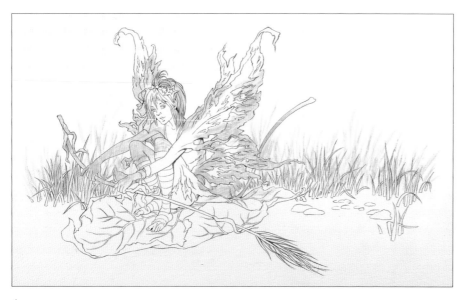

1 Trace off the image and paint over the outline following the instructions on page 9. Using an old no. 2 round brush, put in the masking fluid around the edge of the upper part of the picture. Loosely paint in the background reeds over those in the foreground by flicking the brush upwards. These areas will remain white after the first background wash has been added.

2 Mix 4 parts raw sienna and 1 part Indian red, then add a touch of gold ochre gouache to thicken it and make it a little more opaque. Pick up some colour with a no. 10 sable/synthetic flat brush, remove the excess on a spare piece of paper, and use dry brushing to loosely 'flick in' the fine reeds behind the fairy. Flick the brush from the base upwards to achieve the desired effect.

Tip
Always allow masking fluid to dry naturally – drying it with a hairdryer can cause it to adhere to the paper, making it difficult to remove without tearing. Clean the brush with which you applied the masking fluid using pure turpentine.

3 While the paint is still wet, turn the brush on its side and make a few broader strokes.

4 Remove all the masking fluid.

5 Add more Indian red to the mix to make it 1 part Indian red to 1 part raw sienna, then add 4 parts water to 1 part colour. With a no. 4 pointed round brush, flick a little of the darker colour here and there to break up the background.

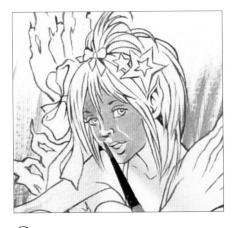

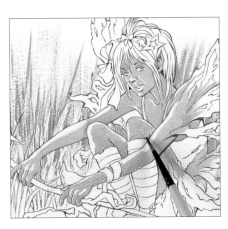

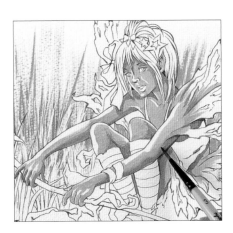

6 Using clean water, mix 4 parts Chinese white and 1 part burnt sienna with a tiny touch of yellow ochre for the flesh tones. With a no. 2 round brush, put the colour on to the face, leaving white highlights around the left-hand edges.

7 Continue to add the flesh tone to the rest of the body using a no. 3 round. Leave white highlights where the light is reflected off the tops of the arms and legs, and the knuckles of the hands. Blend the flesh tone into the base of the wings.

8 Allow the paint to dry, then add a little burnt umber to the mix. Add 4 parts water to 1 part colour and put in the darker tones under the hair around the face and shoulders, on the undersides of the arms and underneath the legs. Use the no. 2 and the no. 3 brushes. Soften in the edges with a clean, damp brush.

9 Add a touch of light red to some cadmium orange, and make a separate mix of gamboge yellow. Beginning with the orange, use a no. 4 pointed round brush to put some colour on to the middle section of the wings. While it is still wet, rinse out the brush, pick up some yellow and place it a tiny distance below the orange, allowing the orange to run down into it.

Tip
To swap quickly between two different colours, load two brushes, one with each colour, and stand one on a brush stand while you are using the other.

23

10 Return to the orange and add a little more colour to the painting, allowing it to blend into the yellow. Continue to work quickly, alternating between yellow and orange, until the middle section of each of the foreground wings is painted.

11 Work the fairy's other wings in the same way. Once finished, rinse out the brush, remove any excess water and soften the edges. Allow the paint to dry.

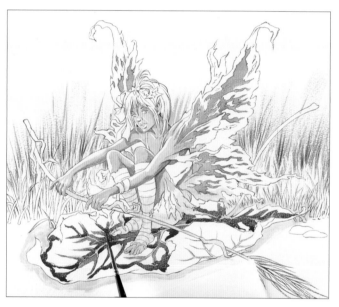

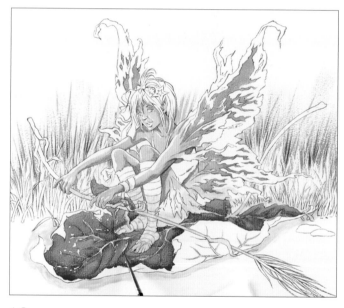

12 Using an old no. 2 brush, mask out the veins on the leaf, the area around the leaf, and the lower parts of the fairy. Mix some alizarin crimson and Indian red in equal amounts, and add 5 parts water to 1 part colour. Flood the colour into the leaf, around the veins and the curled leaf edge, using a no. 4 pointed round brush.

13 While the paint is still wet, and using the mix of cadmium orange and light red mixed 4 parts water to 1 part colour, flood colour quickly into the areas between the veins, allowing it to blend with the red. Work fast and leave a few tiny white patches so that you can drop in another colour later.

14 Use the brush to lift out any excess colour and allow to dry. Work now on the folded side of the leaf, flooding in the red colour where the leaf meets the water and around the veins.

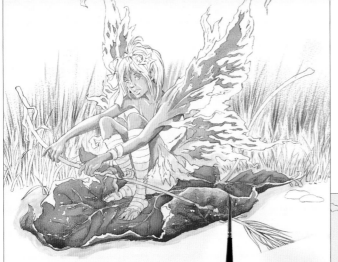

15 Introduce the orange mix and work wet-in-wet, avoiding the top edge. Leave some tiny patches of white as before. Rinse out the brush and soften the colour into the white edge, lifting out any surplus paint to retain a strong contrast. Allow the paint to dry.

16 Remove the masking fluid and mask out the lower parts of the reed stems, the rocks on the water and some ripples on the water around the leaf and the fairy's paddle. Allow the masking fluid to dry.

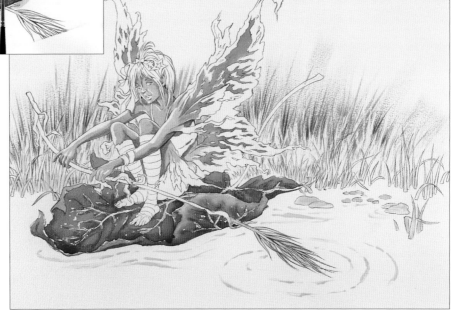

17 For the water, mix 2 parts sap green with 1 part light red, then add 4 parts water to 1 part colour. With a fairly well loaded no. 6 round, lay colour around the edge of the leaf leaving a white border, then stroke on the colour in lines following the curve of the ripples. Lay the paint over the masking fluid and leave plenty of white space.

18 Use a clean, damp brush to soften some of the edges and allow the paint to dry.

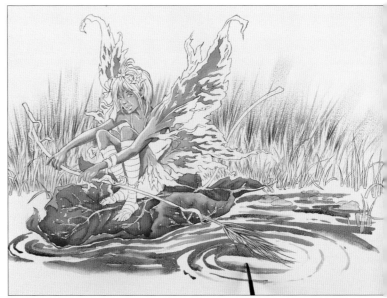

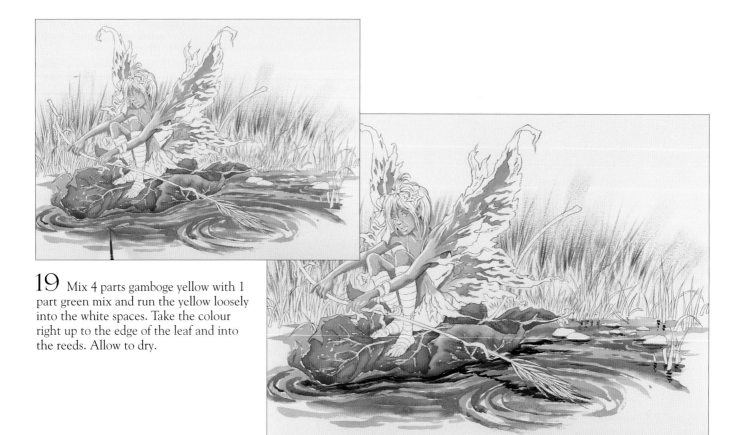

19 Mix 4 parts gamboge yellow with 1 part green mix and run the yellow loosely into the white spaces. Take the colour right up to the edge of the leaf and into the reeds. Allow to dry.

20 Remove the masking fluid, then, using a watery mix of gamboge yellow and the no. 4 pointed round brush, run a little yellow into some of the whites to knock them back. Allow the paint to dry. Make a dark, rich green by mixing 2 parts sap green with 1 part dioxazine violet, then adding water in the ratio of 1 : 1. Spot the colour on to the water to create reflections under the leaf, rocks and paddle. Allow to dry.

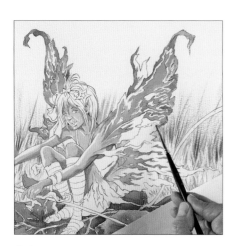

21 Mix 1 part Hooker's green light with 2 parts gamboge yellow, then add 4 parts water to 1 part colour. Use a no. 2 pointed round to run some green loosely around the edges of the wings, stopping just short of the yellow to avoid the two colours mixing. Allow the paint to dry.

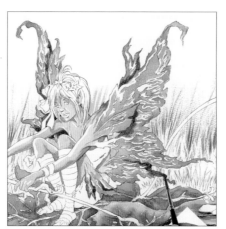

22 Now make a mix of 4 parts Hooker's green light and 1 part dioxazine violet, and add 2 parts water to 1 part colour. Use a no. 4 pointed round to run this colour into the shadows, where two wings or parts of wings overlap. Allow the paint to dry.

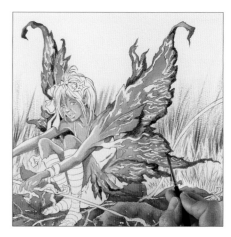

23 Use the same colour and the no. 4 brush to strengthen the edges of the wings. Apply the colour loosely, then soften any hard edges with a clean, damp brush.

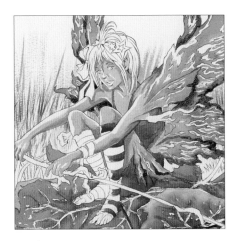

24 Mix 1 part alizarin crimson with 2 parts water and use a no. 4 brush to put in the fairy's dress. Allow the paint to dry. Using the same mix, put in the stripes on the fairy's sock, leaving the front edge white.

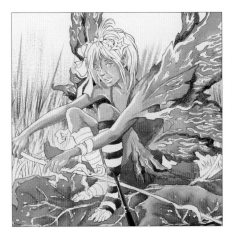

25 Before the paint dries, add dioxazine violet to the same red mix (1 violet : 2 red), and drop a little of the darker red into the right-hand side of each stripe. Soften the dark red into the lighter red using a clean, damp brush, then wash out the brush and soften the lighter red into the white.

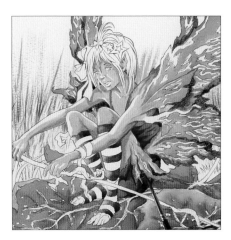

26 Allow to dry, then paint the other sock in the same way. With the same dark red mix, create some folds and creases in the fairy's dress.

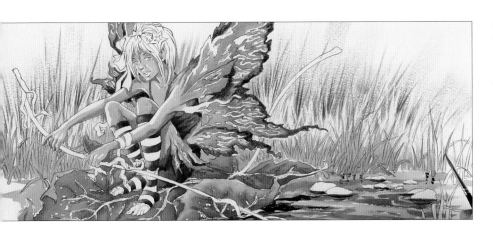

27 Lay a light wash of gold ochre loosely over the reeds in the background using the no. 4 pointed round brush. Allow to dry.

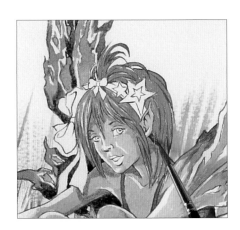

28 Mix 2 parts cadmium orange and 1 part light red, then add 2 parts water to 1 part colour. Use a no. 3 pointed round brush to put in the base wash for the hair.

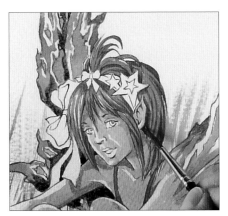

29 Add a little more dioxazine violet to the mix and lay in some darker tones.

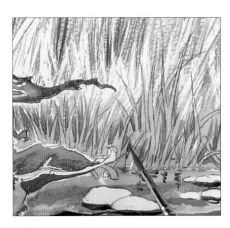

30 Use a mix of 2 parts gold ochre and 1 part burnt umber, mixed with 3 parts water to 1 part colour, to darken the area behind the reeds.

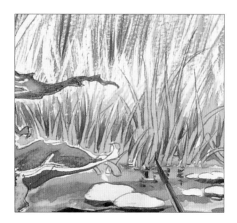

31 Add a little dioxazine violet to the mix and touch in the darker colour here and there in between the reeds to add depth.

32 With Payne's gray and Chinese white mixed in equal amounts, then mixed with 3 parts water to 1 part colour, shade in the darker side of the white stripes on the socks, then soften the edges using a clean, damp brush.

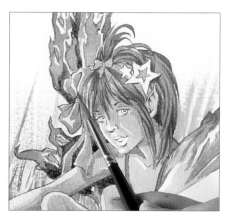

33 For the ribbons and star in the fairy's hair, use gamboge yellow and a touch of light red, mixed with water in the ratio of 1 : 1. Lay in the colour using a no. 3 pointed round, and leave a small white highlight. Allow to dry, then add a little more light red to the mix and use it to define the darker parts of the ribbon.

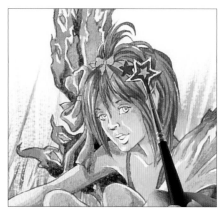

34 Using the same red mix of alizarin crimson that you used for the dress, with a no. 2 pointed round brush paint in the little red stars in the fairy's hair.

35 Mix 1 part gold ochre with 3 parts water and use the same brush to run colour over the leaf stem. Leave a white highlight on the upper edge.

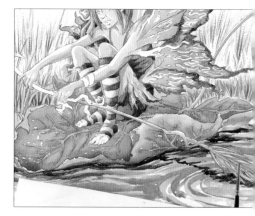

36 With the same colour, put in the veins on the leaf, retaining the small white areas. Also add colour to the paddle, again leaving the highlights white.

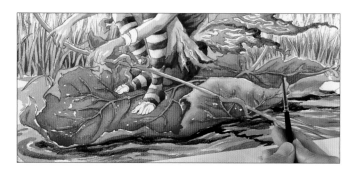

37 Using a no. 1 sable round, run a dark mix of dioxazine violet and burnt umber in equal amounts along the undersides of the veins.

38 Change to a no. 4 pointed round and use the same colour to darken the shadows under the curled edge of the leaf and behind the fairy's legs.

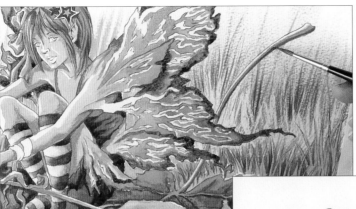

39 Run the same colour along the underside of the leaf stem.

40 Mix some permanent white gouache with clean water until it is the consistency of single cream. With a well-loaded no. 0 brush, lightly spot the colour here and there, where the leaf touches the water. Also add some to the water itself to make it sparkle.

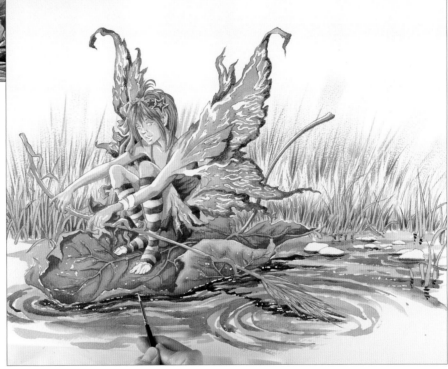

41 With burnt umber and a no. 0 brush, paint in the irises of the eyes. Rinse out the brush and use it to soften the highlights.

42 Paint in the lips, leaving a highlight, using cadmium red deep and Chinese white mixed 1 part colour with 4 parts water.

43 Mix 1 part burnt umber with 1 part Chinese white and 2 parts Payne's gray, then add 4 parts water to 1 part colour to the mix. Run the colour loosely into each rock, leaving a highlight on the top. Soften the colour in with a damp, clean brush.

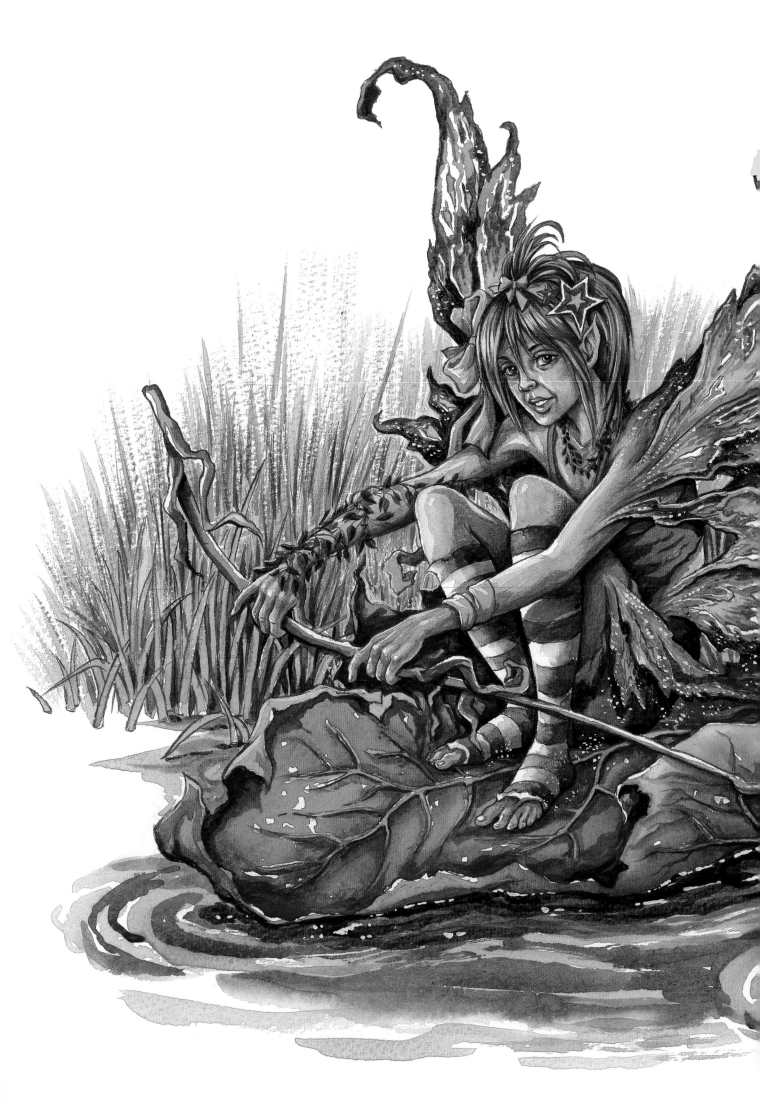

A Paddle in a Puddle

I brushed a thin mix of intense green and gold ochre, mixed 1 part colour with 4 parts water, into the reeds in the background. I have darkened the deeper recesses within the reeds with a mix of gold ochre and dioxazine violet, and overpainted some areas of the reed bed using gold ochre mixed 1 part colour to 4 parts water and applied with a no. 4 sable brush. To further model the face I have used a thin mix of burnt sienna, Chinese white and burnt umber; the deeper shadow areas on the legs and arms have been enhanced with the same mix. With a pointed round no. 4 sable brush, I have painted darker ripples on the water using a mix of intense green and dioxazine violet, particularly around the bottom of the leaf and in the reflection from the grass-stem paddle. Using the same brush, I have introduced a thin mix of gold ochre randomly here and there. On the wings, I have added a fairly strong mix of phthalo green and dioxazine violet to the edges and deeper recesses, particularly behind the figure. I have also deepened the gold areas in places using a mix of gold ochre, alizarin crimson and a little dioxazine violet.

Finally, I have darkened the deeper recesses and shadows on the leaf with a reasonably strong mixture of Indian red and dioxazine violet, paying particular attention to the area behind the hand and the leg. I have also added a creeping ivy to the right arm and an ivy necklace using phthalo green, with dioxazine violet added to it for the areas in shadow. A no. 1 pointed sable was used.

Lady Orchid

TRACING 4

This project was built around an image I found whilst looking at some photographs of slipper orchids. The jewel of these strange and beautiful plants is the Lady Orchid. I now had the title for the painting, which led me to creating this exotic, queen-like fairy.

You will need

Watercolour paper: 425gsm (200lb) rough finish, 56 x 38cm (22 x 15in)

Watercolours: burnt sienna, burnt umber, raw sienna, Chinese white, gamboge yellow, cadmium orange, light red, dioxazine violet, mauve, cobalt violet, perylene maroon, cadmium red deep, alizarin crimson, ivory black, Hooker's green light

Brushes: nos 1, 2, 3 and 4 pointed round sable; no. 6 sable/synthetic mix

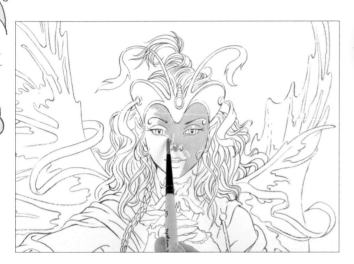

1 Trace off the image and paint over the outline following the instructions on page 9. Beginning with the flesh tone, make a mix of 3 parts burnt sienna, 1 part Chinese white and 1 part raw sienna, then add 3 parts water. Flood the colour on to the face using a no. 3 round brush, leaving some white highlights. The light is coming from the left.

Tip
Make sure you mix enough colour for all the flesh tone on the fairy's body, not just the face.

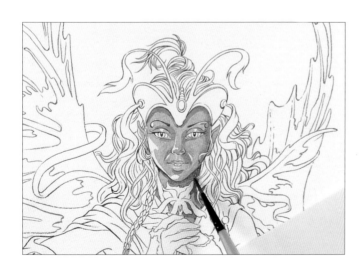

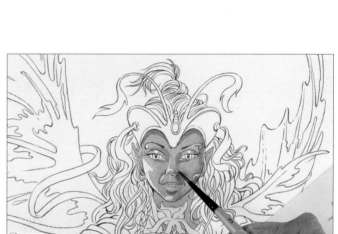

2 Take the colour over the lips, leaving a highlight, and down into the neck. Work delicately and avoid overpainting, which may lift the outline underneath. There is no need for highlights on the neck, as this part will be in shadow. While the paint is still wet, add a little burnt umber and some more burnt sienna to the mix and put in the shadows on the face. Allow the paint to dry.

3 Soften the edges of the shadows with a clean, damp brush. Make a slightly stronger version of the mix and put in the shadows under the chin and to the side of the neck using wet-on-dry. Allow the paint to dry (these shadows will be softened in later).

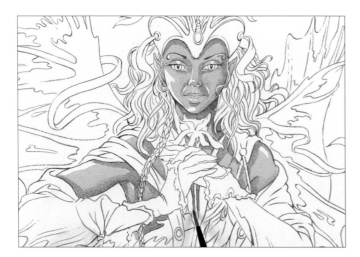

4 Using the original flesh-tone mix, take the colour down into the upper arms and body, leaving highlights as before. Use the slightly darker mix to put in the shadows under the arms and around the shoulders using wet-in-wet. Allow to dry.

5 Run the original flesh-tone mix down into the lower arms, fading the colour out into the wings. Using wet-in-wet, run the slightly darker mix under the arms and fabric. Allow the paint to dry.

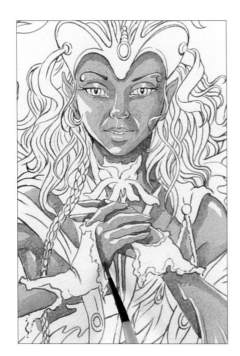

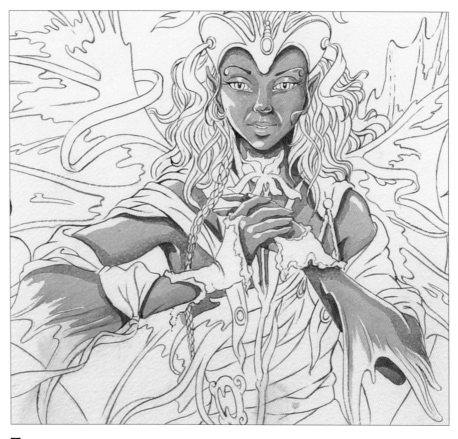

6 Change to a no. 2 brush and carefully paint in the hands using the original flesh tone. Leave a white highlight on the top of the fingers. Allow the paint to dry, then with the slightly darker mix put in the shadows under the fingers and the fabric.

7 With the stronger version of the darker mix and the no. 2 brush, use wet-on-dry to strengthen the darkest shadows, for example under the arms and wings; under the fabric wrapped around the arms and body; beneath the chin and under the headdress. Add a touch of the dark mix to the inner recesses of the ears and the tip of the nose, softening these in with a clean, damp brush.

8 For the hair, mix gamboge yellow with a little cadmium orange and darken it with a touch of light red. Paint in each section of the hair carefully with the no. 2 brush, leaving white highlights here and there.

9 Add some more light red to the yellow mix and darken the right-hand side of each section of hair. Also lay the darker tone into the deeper recesses of the hair and behind the headdress. Darken the hair on the right-hand side of the fairy more than that on the left, but still allow plenty of the original colour to show through.

10 Change to a no. 1 sable round and add a little dioxazine violet to the deeper yellow mix to make a fairly thick brown. Strengthen the darkest recesses of the hair, including those under the headdress and beneath the tassels.

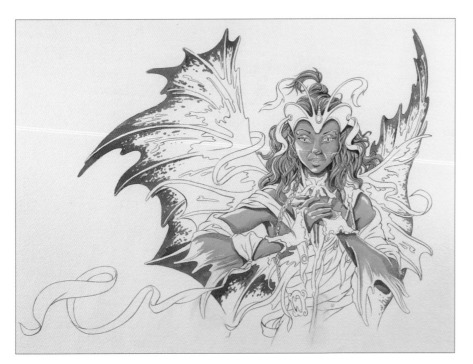

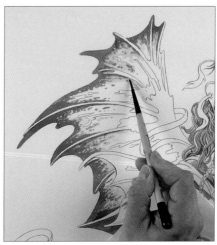

12 Change the water and soften in the colour with a clean, damp brush. Smudge the colour, but avoid merging it into a single block of colour. Work from the top of the wing downwards.

11 Mix some mauve with dioxazine violet (1 part colour to 4 parts water) and run the colour around the edge of the left-hand wing. Use the no. 3 brush. There is no need to be too precise. Stipple the colour on leaving a few tiny white marks, and dab it on in spots towards the inner part of the wing. Repeat on the right-hand wing, where the edge is visible.

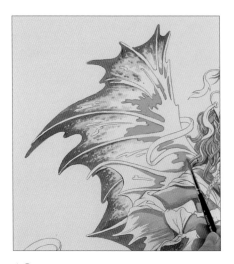

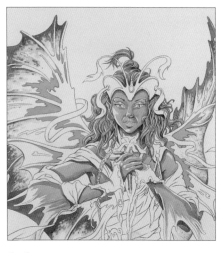

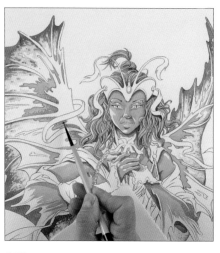

13 Make a strong mix of 3 parts gamboge yellow and 1 part cadmium orange and put the colour on to the inner parts of the left-hand wing. Use a no. 4 pointed round brush and keep within the drawn shapes.

14 Continue on the right-hand wing and allow to dry.

15 Add 1 part mauve to the mix and use a no. 2 round brush to spot the deeper colour into the recesses of the yellow shapes and along the veins using wet-on-dry.

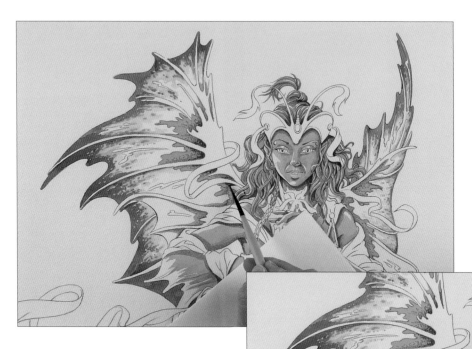

16 Add more mauve to the mix (so it is now 3 parts mauve) and stipple the darker colour into the deepest recesses in the yellow patterns on the wings.

17 Mix up some cobalt violet (1 part paint to 4 parts water) and use a well-loaded no. 4 pointed round brush to paint the small, lower wings. Spot the colour on, as you did the purple. Soften with a clean, damp brush.

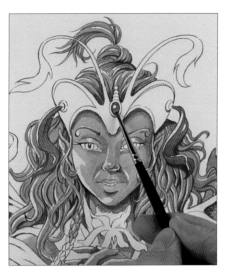

18 Mix 1 part perylene maroon with 1 part cadmium red deep, and add 4 parts water. With a no. 4 pointed round brush, paint the bands of ribbon clothing the fairy's body. Leave a white highlight along the top of each band, and leave the bottom edge fairly loose. Soften with a clean, damp brush and allow to dry.

19 With the same red mix and a well-loaded no. 3 round brush, put in the ribbons in the fairy's hair, leaving highlights as before. Change to a no. 1 brush and put in the ruby in the centre of the headdress.

20 Darken the red by adding 2 parts dioxazine violet to 3 parts red and brush it into the darker recesses of the dress. Allow to dry.

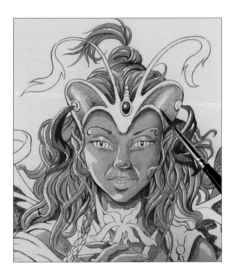

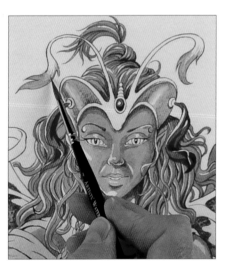

21 Use the same mix to darken the shadows underneath the ribbons and around the ruby. Mix 1 part cobalt violet with 3 parts water and paint in the headdress, leaving a strong highlight down the centre. Allow to dry, then soften in the colour on either side.

22 Use the same colour on the ends of the feathers attached to the headdress.

23 With the gamboge yellow, cadmium orange and mauve mix (see step 15), paint in the edges of the small wings attached to the lower arms using a no. 4 pointed brush. Apply the colour at the edges of the wings and blend it into the flesh tone.

24 Add some more mauve to the mix to make a brown and paint in the ridges.

25 Mix 1 part gamboge yellow with 4 parts water and lay colour over the ribbons and fabric wrapped around the fairy's arms and shoulders. Use a fairly well loaded no. 6 brush for the larger areas and a no. 3 for the detailing. Leave highlights along the top edges.

26 With the no. 3 brush, add some mauve to the gamboge and put in the darker, shaded areas on the yellow ribbon and fabric. Soften the edges of the shadows with a clean, damp brush.

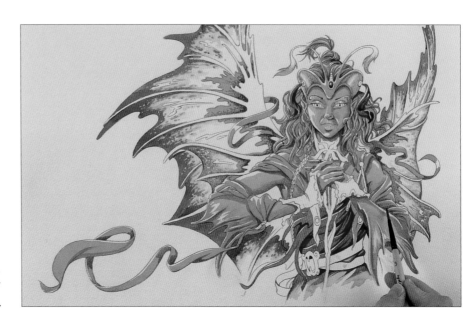

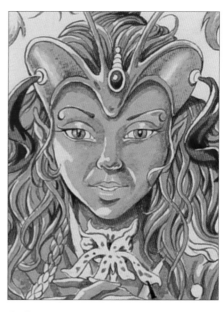

27 Use the same colour to touch in some darker shadows on the gold part of the headdress to give the impression of a reflective metal surface.

28 With the same cobalt violet mix that you used on the headdress, paint in the gloves leaving highlights and a white edge.

29 Use the same mix to put in the irises of the fairy's eyes with a no. 1 brush. Leave a tiny highlight in each eye. Mix some mauve with a touch of the cobalt violet mix and spot in some colour on the flower. Soften in the marks with a clean, damp brush.

30 With the same mix and the same brush, darken the shaded areas on the gloves. Allow the paint to dry.

31 Mix some alizarin crimson and cadmium red deep, and water it down with 4 parts water. Paint in the lips, leaving a tiny highlight, and soften the edges.

32 Using a no. 4 pointed round brush, put in the belt using ivory black. Leave some white patches here and there.

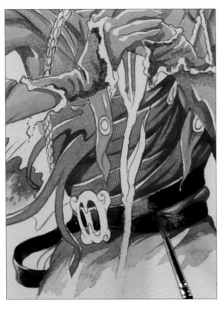

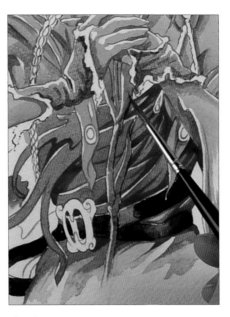

33 Use mauve to put some colour into the white patches using wet-in-wet. Leave some white highlights. Soften the edges of the purple with water, pushing them back into the black.

34 Mix 2 parts Hooker's green light with 1 part gamboge yellow, then add some water to make a fairly watery mix. With the no. 4 pointed round, fairly well loaded with colour, put in the leaves and stem of the flower. Leave a white highlight down the left-hand side.

35 Make a fairly strong mix of 1 part Hooker's green light and 2 parts water and put in the shadows on the leaves and stem – under the hands and down the right-hand side. Allow to dry.

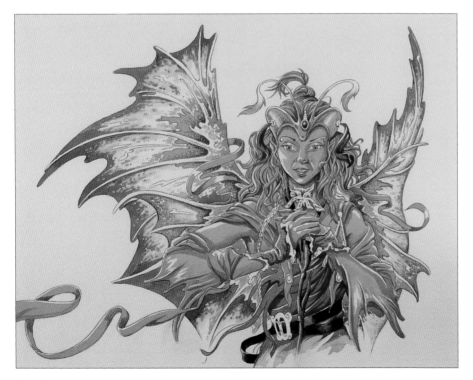

36 Using a mix of 1 part Payne's gray, 4 parts Chinese white and 1 part mauve, add colour to the remaining white areas of the wings. Give the grey a ragged edge and soften it in afterwards with a clean, damp brush.

37 With the same colour and using the same brush, add colour to the buckle, leaving bright highlights to emphasise its metallic nature.

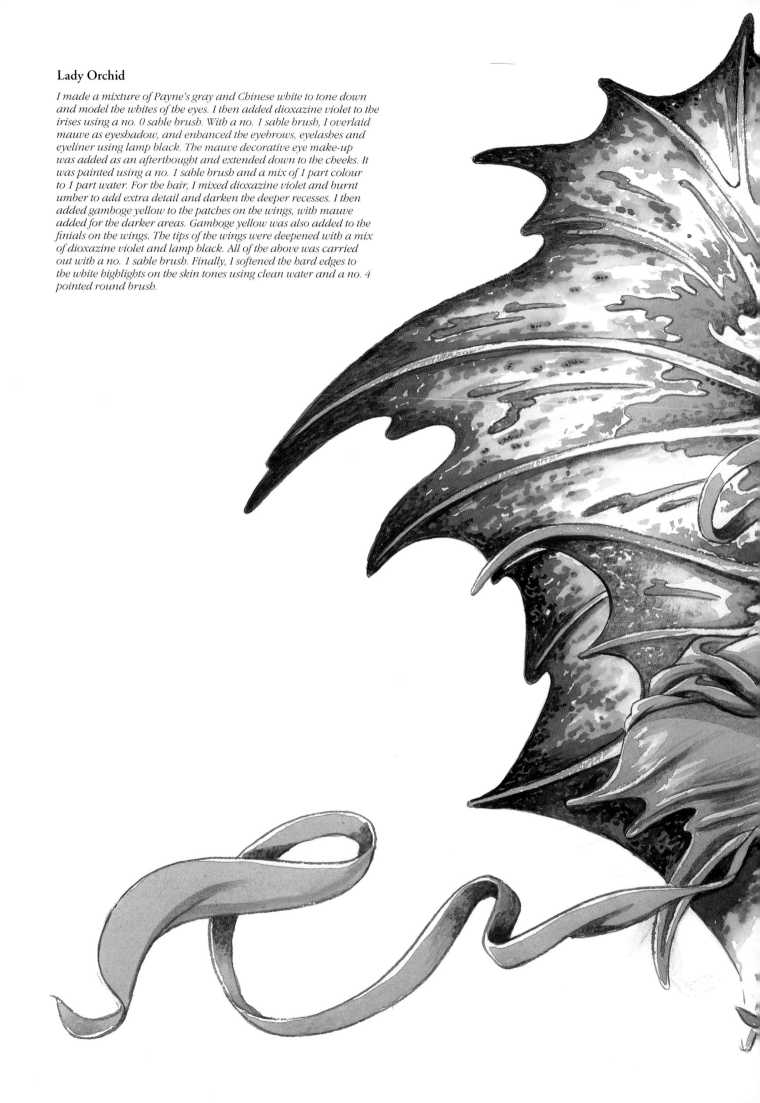

Lady Orchid

I made a mixture of Payne's gray and Chinese white to tone down and model the whites of the eyes. I then added dioxazine violet to the irises using a no. 0 sable brush. With a no. 1 sable brush, I overlaid mauve as eyeshadow, and enhanced the eyebrows, eyelashes and eyeliner using lamp black. The mauve decorative eye make-up was added as an afterthought and extended down to the cheeks. It was painted using a no. 1 sable brush and a mix of 1 part colour to 1 part water. For the hair, I mixed dioxazine violet and burnt umber to add extra detail and darken the deeper recesses. I then added gamboge yellow to the patches on the wings, with mauve added for the darker areas. Gamboge yellow was also added to the finials on the wings. The tips of the wings were deepened with a mix of dioxazine violet and lamp black. All of the above was carried out with a no. 1 sable brush. Finally, I softened the hard edges to the white highlights on the skin tones using clean water and a no. 4 pointed round brush.

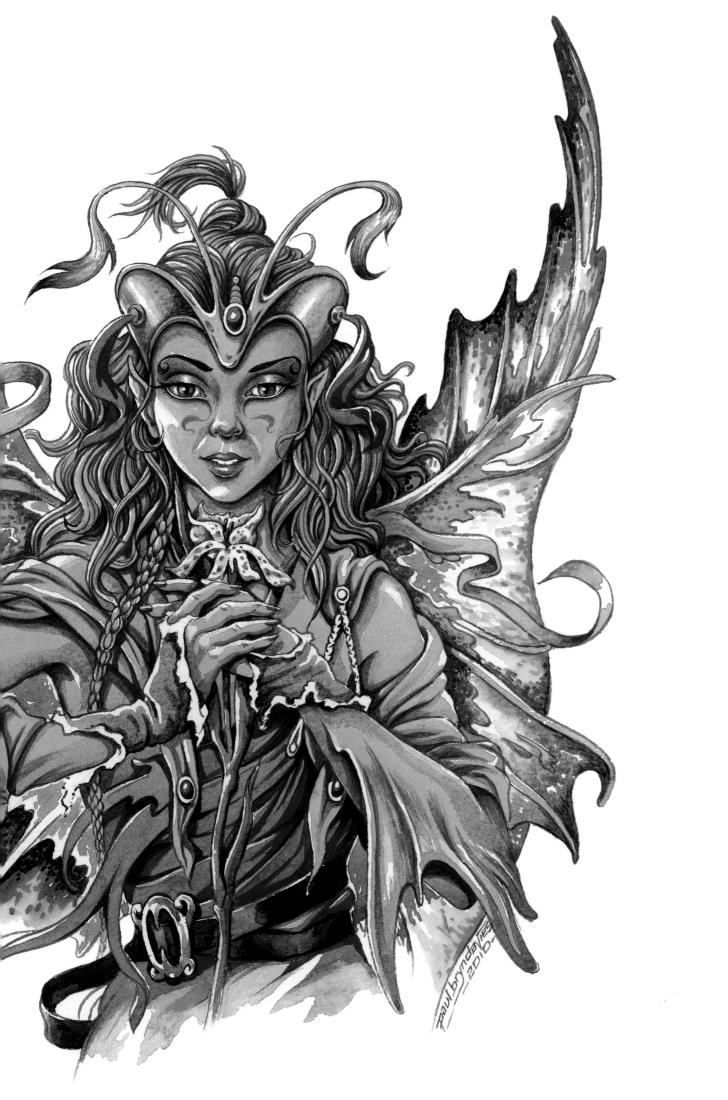

The Dune Glider

*I*wanted to paint a fairy in flight using a very limited palette, and so the dune glider was born. The painting benefits from the very simple fantasy backdrop that I used to set the scene.

You will need

Watercolour paper: 425gsm (200lb) rough finish, 56 x 38cm (22 x 15in)

Masking fluid

Watercolours: Payne's gray, Chinese white, gold ochre, dioxazine violet, burnt sienna, burnt umber, alizarin crimson, mauve

Gouache: permanent white

Brushes: nos 0, 1, 2 and 4 pointed round sable; no. 6 sable or sable/synthetic mix; nos 6 and 10 synthetic flat; an old no. 2 or no. 3 brush for the masking fluid application

1 Trace off the image and paint over the outline following the instructions on page 9. Paint on a thick coating of masking fluid over the fairy, avoiding the gaps in the wings, taking it down to just below the horizon. This will allow you to flood in a loose background wash.

2 Mix 1 part Payne's gray and 3 parts Chinese white with 5 parts water. At the same time, make a mix of 1 part gold ochre, 2 parts Chinese white and 4 parts water. Test both colours on a blank piece of paper. Using a no. 10 flat brush, lay on the grey in the sky area using broad, horizontal strokes. Allow the brushstrokes to remain visible at the edges. Make the colour slightly darker at the top of the picture, and take it down to just below the top of the distant mountain.

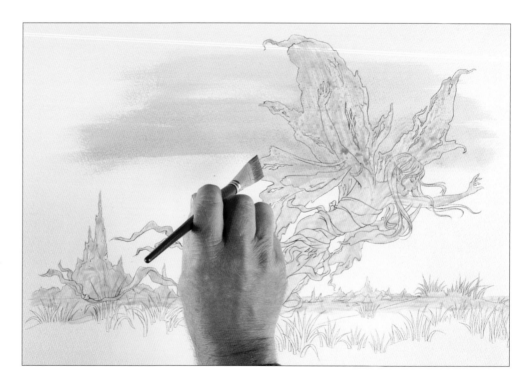

3 Clean the brush and wet the bottom edge of the paint, then run in the gold ochre and blend it into the wet edge.

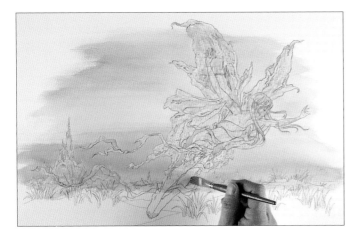

4 Rinse out the brush in cold water. Change to a no. 6 flat brush, dampen it and lift out some of the colour from the horizon. Allow to dry.

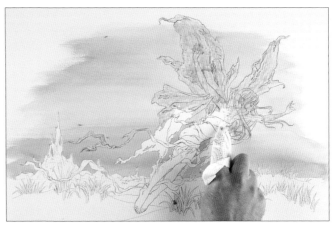

5 Remove all of the masking fluid with a piece of kitchen paper wrapped around your index finger.

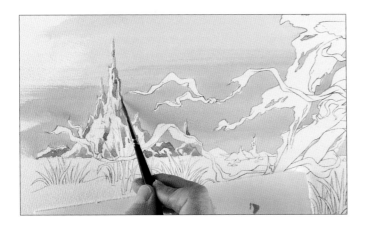

Tip

The light is coming from the top left; draw in a tiny sun to remind you.

6 Mix 1 part Payne's gray with 2 parts Chinese white and a touch of dioxazine violet, then add 5 parts water to 1 part colour. With a no. 4 pointed round, run the colour down the left-hand side of the distant mountains and put in the shadows around the rocky outcrops. Paint carefully around the ribbons.

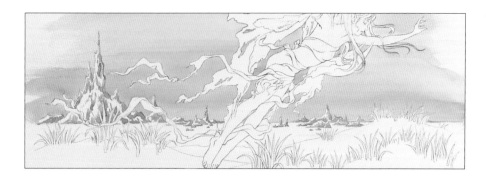

7 Continue putting the violet shadows into the background rocks to the right-hand side of the picture.

8 Deepen the yellow mix by adding more gold ochre to it, then flood the colour into the top part of the sea, below the rocks and mountains. Leave a thin white line between the land and the sea.

9 Rinse out the brush and wet the bottom edge of the yellow so that you can blend in the next colour. Quickly add a touch more dioxazine violet to the violet mix to strengthen it and run it into the wet edge. Pull the colour down towards the foreground.

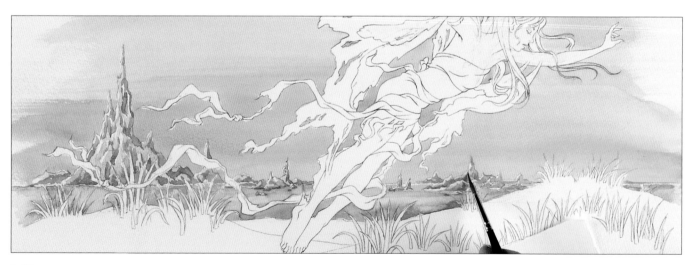

10 If necessary, soften the edge where the yellow band meets the violet, and lift out any colour you feel is too strong. Add another 3 parts water to the original violet mix (see step 6) and run this over the surface of the rocks and mountains, leaving some white highlights. Use just a single brushstroke over the existing shadows to avoid lifting out the colour. Allow to dry.

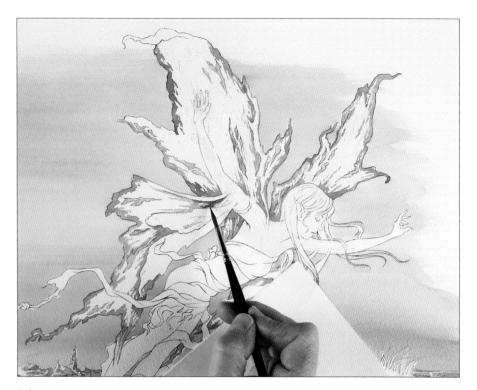

11 Add a little more dioxazine violet to the stronger violet mix (see step 9) and use the no. 4 pointed round to paint loosely round the edges of the wings. Use the side of the brush and a shaky hand to give the colour a wavy inner edge, and put a few random spots of colour here and there.

12 On the smaller wings, leave a narrow white border at the edge of the wings to separate them from the larger wings behind.

13 Add a little more dioxazine violet and Payne's gray to the mix and darken the shaded areas behind the head and arms and under the smaller wings. Again, use a shaky hand to achieve a wavy edge. Start to put in the flesh tones using a mix of 1 part burnt sienna, 3 parts Chinese white and a touch of gold ochre. Mix this with 6 parts water to 1 part colour. Test the colour on a spare piece of paper before applying it to your painting. Leave highlights on the tops of the arms and backs of the body and legs.

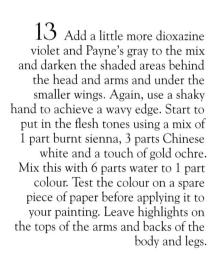

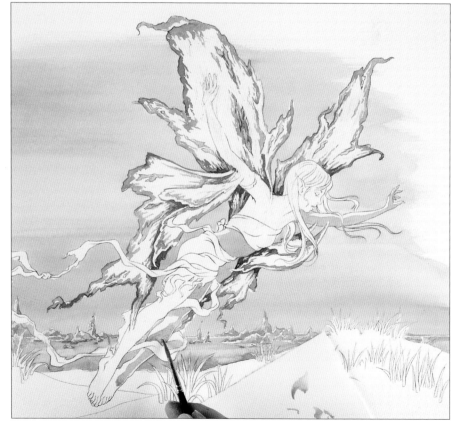

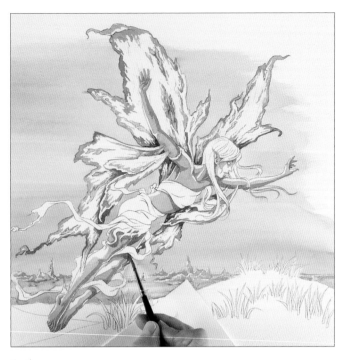

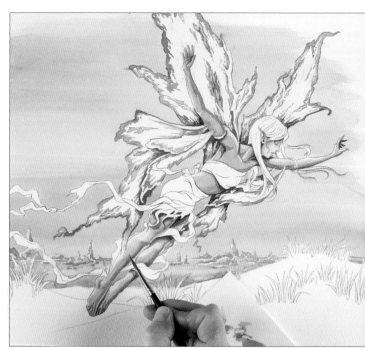

14 Complete the flesh tones and allow the paint to dry. Add a touch of burnt sienna and burnt umber to the mix and lay this mid tone wherever a shadow falls on the fairy's skin – under her chin, ear and hair; on the undersides of her arms; and under the fabric of her clothing. Allow the shadows to dry, then soften in the edges of the lighter skin tone using a clean, damp brush.

15 Darken the mid tone with a touch of dioxazine violet and run it under the chin, hair and armpits, on the undersides of the fingers and around the ear. Use a no. 2 pointed round brush. Move down to the lower part of the body and place the darker tone between the thighs, on the front of the legs and feet, between the toes and beneath the cloth skirt. Overlay the mid tone and soften the edge of the darker shadow as you work. Allow to dry.

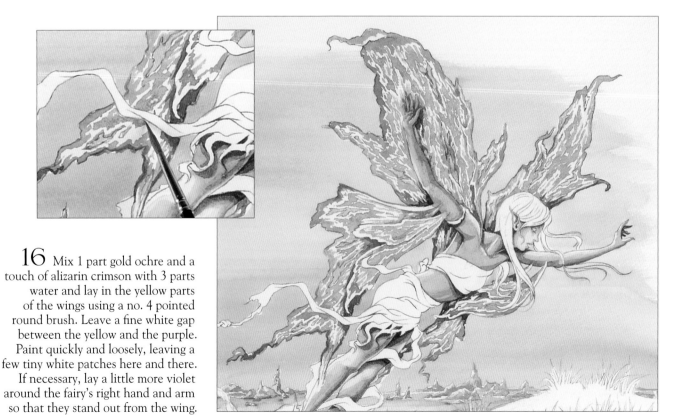

16 Mix 1 part gold ochre and a touch of alizarin crimson with 3 parts water and lay in the yellow parts of the wings using a no. 4 pointed round brush. Leave a fine white gap between the yellow and the purple. Paint quickly and loosely, leaving a few tiny white patches here and there. If necessary, lay a little more violet around the fairy's right hand and arm so that they stand out from the wing.

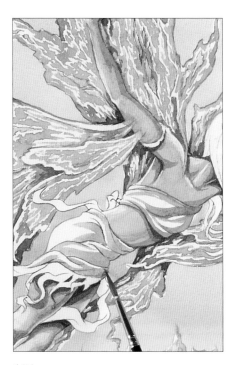

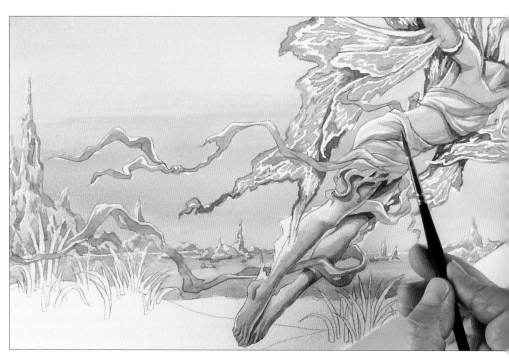

17 Mix 2 parts mauve with 1 part Chinese white and a touch of Payne's gray. Add 4 parts water to 1 part colour. Paint this on to the fairy's clothes, following the folds of the fabric. Leave white areas for a paler tone to be added in the next step.

18 Continue the colour into the ribbons, avoiding the highlights. Using the same mix, add another 4 parts water and lay the paler mix into the white areas, leaving some white highlights. Where you lay the paler tone over the first layer of paint, use only a single brushstroke to avoid lifting the darker colour. Allow the paint to dry.

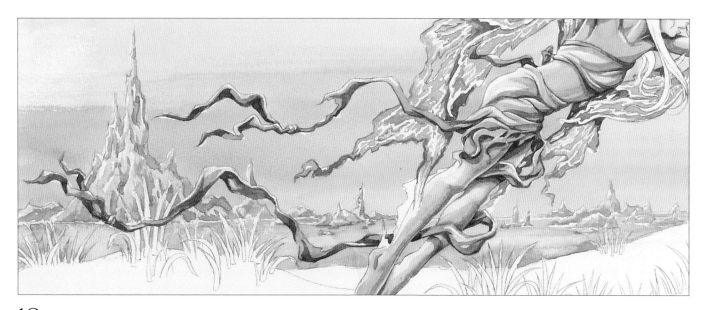

19 Mix 1 part Payne's gray with 2 parts dioxazine violet, then add 3 parts water to 1 part colour. Use this to put in the deepest folds on the fairy's clothes.

Tip

Try out new mixes on a piece of scrap paper to make sure you are happy with the colour before applying them to your painting.

47

20 For the hair, mix 1 part gold ochre with 1 part Chinese white and add 3 parts water to 1 part colour. Brush the colour on to the hair using a no. 4 pointed round, leaving white highlights on the hair on top and towards the back of the head. Allow to dry.

21 Make a mix of gold ochre with a little mauve and dioxazine violet added to it and, using a no. 2 brush, darken the hair around the fairy's face so that her profile stands out. Use the same mix to add shadows elsewhere in the hair to give it depth.

22 Mask out the fairy's feet and allow the masking fluid to dry thoroughly. Make a watery mix of 1 part gold ochre, 4 parts Chinese white and 1 part burnt umber by adding 8 parts water to 1 part colour, then lay on the sand loosely using a no. 6 round brush. Paint freely, leaving white patches here and there. Allow to dry.

23 Add a touch of mauve to the mix and lay in some loose patches of the darker colour, working wet-on-dry. This will add depth to the scene. Allow the paint to dry.

24 Add some dioxazine violet to the mix used in the previous step and use an upwards flicking movement of the brush to put in the distant grasses. Place a few horizontal lines beneath the grasses to represent shadows.

25 For the foreground grasses, use the same mix and paint carefully within the drawn outlines. Again, run the same colour underneath the grasses to form shadows.

26 Flick in some darker areas using 1 part dioxazine violet mixed with 2 parts water.

27 Mix up some permanent white gouache to a creamy consistency and lay a little of the white paint on the left-hand sides of some of the grasses.

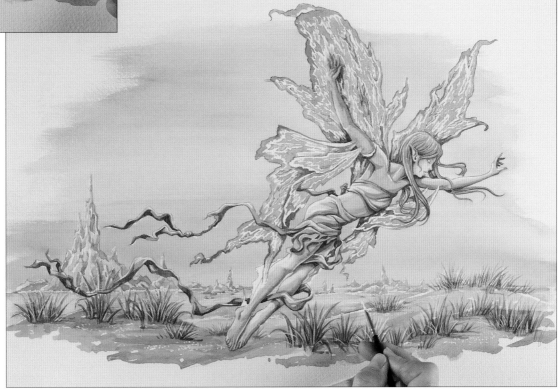

28 Change to a smaller brush (no. 0) and stipple on some tiny spots of white under the rocks in the background and into the water and sand to add texture. Where the water meets the land in the foreground, add a thin white edge to simulate reflected sunlight.

The Dune Glider

I have added detail to the hair using a strong mix of burnt umber and dioxazine violet, then added permanent white gouache highlights with a no. 1 sable brush. Using a no. 4 pointed round brush, the violet-grey areas of the wings have been further modelled with a stronger mix of the same colours. An Indian red and gold ochre mix has been added to the rust colour on the wings.

Finally, I have used burnt umber mixed with dioxazine violet to darken the hair behind the face and under the chin, and to define the hair generally. Extra strands of hair were added using the same mix with a no. 1 brush. The face tones were darkened with a mix of burnt sienna and burnt umber, mixed 1 part colour with 3 parts water.

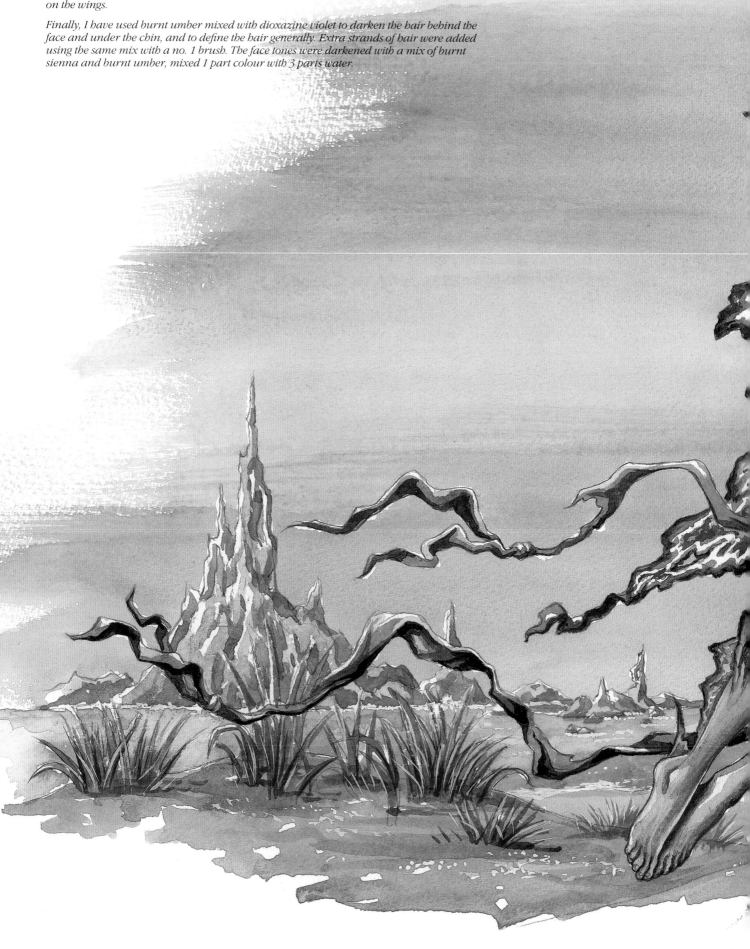

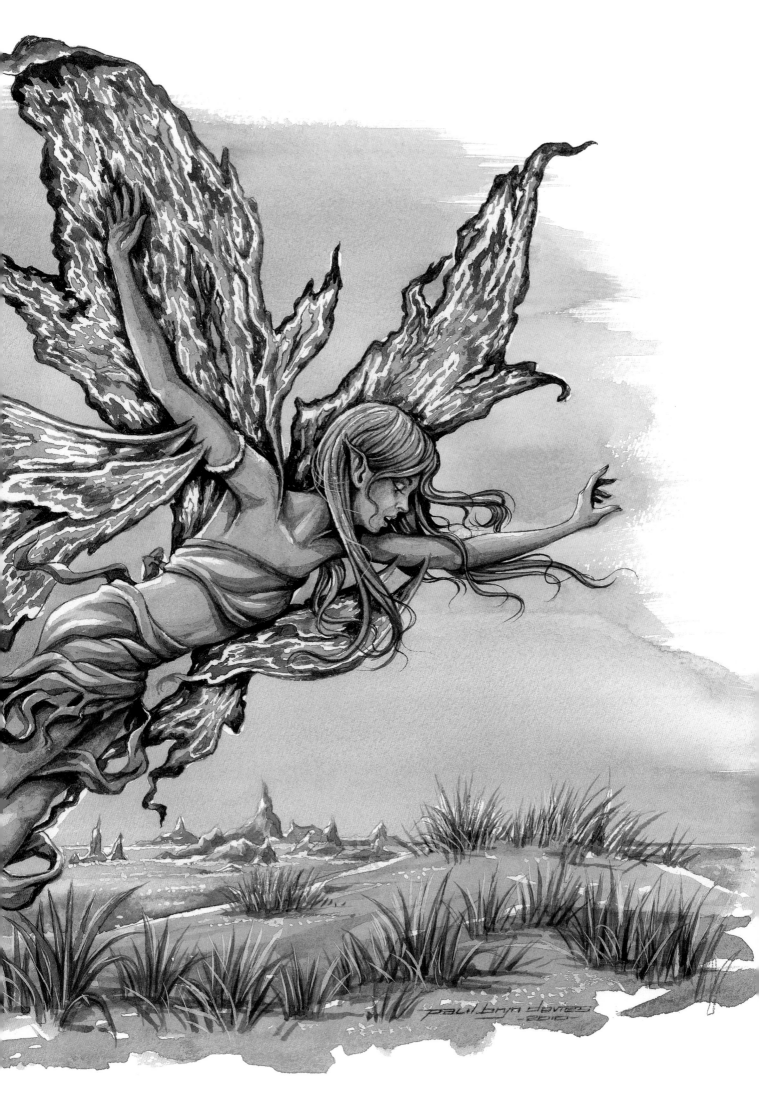

The Ragged Piper

This book would not be complete without the traditional fairy sitting on a toadstool. I know this image is somewhat overdone in fantasy paintings, but it can still create a great setting for your fairy. This painting is more decorative in style than the previous projects, and I wanted particularly to focus on the wings.

You will need

Watercolour paper: 425gsm (200lb) rough finish, 56 x 38cm (22 x 15in)

Masking fluid

Watercolours: mauve, Chinese white, dioxazine violet, Payne's gray, gamboge yellow, burnt sienna, gold ochre, burnt umber, alizarin crimson, cadmium red deep, ivory black, Indian red

Gouache: permanent white

Brushes: nos 0, 1 and 4 pointed round sable; no. 6 sable/synthetic mix; an old no. 2 or no. 3 brush for the masking fluid application

TRACING

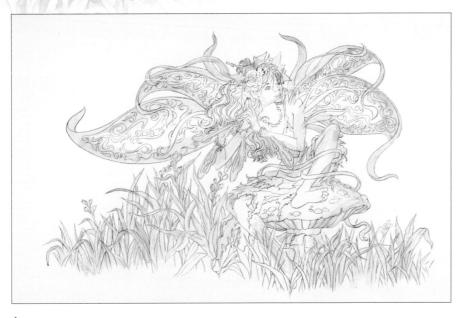

1 Trace off the image and paint over the outline following the instructions on page 9. Paint on a coating of masking fluid around the edge of the fairy and on the top part of the grasses so that a light wash can be applied behind the image.

2 Make three mixes: a watery purple mix consisting of 1 part mauve, 5 parts Chinese white and 6–8 parts water; a pink mix of 1 part dioxazine violet, 1 part Chinese white, a touch of Payne's gray and 8 parts water; and a yellow mix of 1 part gamboge yellow, a drop of Chinese white and 6 parts water. Make plenty of each, to make sure you do not run out. Using a no. 6 brush, dab the purple mix randomly on to the background, leaving a few white patches.

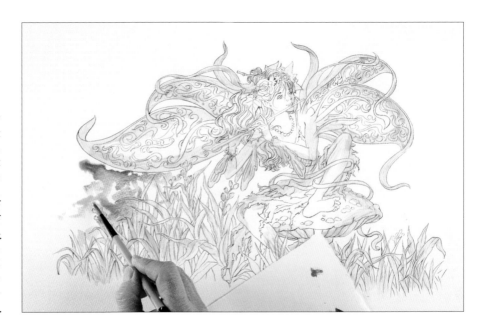

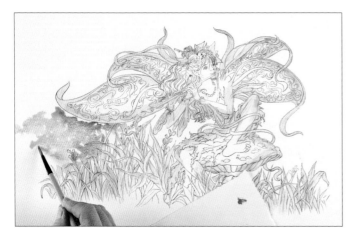

3 Wash out the brush and put in some pink, allowing it to blend with the purple.

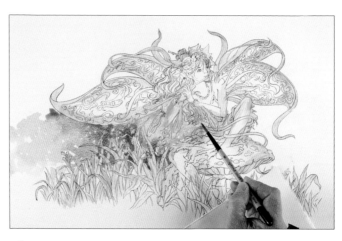

4 Continue to drop in the purple and pink, alternating between the two, and allow them to blend on the paper. Lay the darker colour towards the bottom of the sky, behind the grasses.

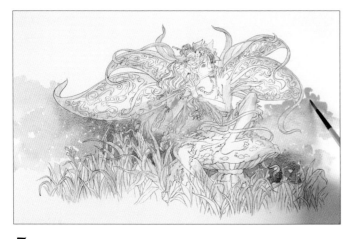

5 Switch to the yellow and drop it into the background while it is still wet.

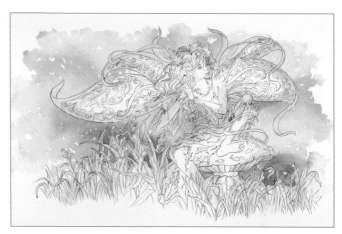

6 Continue painting the sky with these three colours, working fast so that the colours blend without leaving any hard edges. When you are happy with your background wash, allow it to dry.

Tip
Hold the brush near the end of the handle to achieve a loose, less controlled look to your painting, and lift out any excess colour with a clean, damp brush.

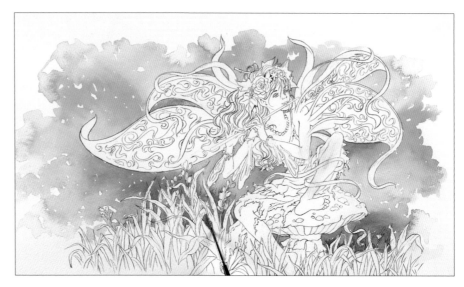

7 Remove the masking fluid and fill in any areas of the background that you have missed. Use a no. 4 pointed round.

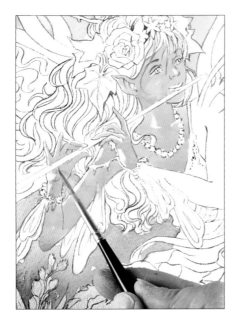

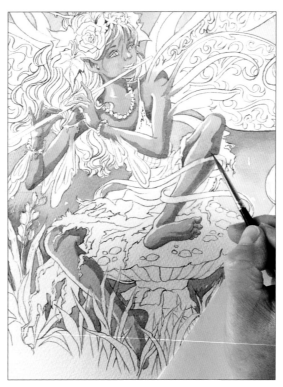

9 Continue down into the legs and allow to dry. Add a little burnt sienna and some burnt umber to the mix to darken it and put in the shadows on the right-hand sides of the limbs, under the fairy's clothing, and under the arms, neck, hair and fingers, and within the ear.

8 Start to put in the flesh tones using a mix of 1 part burnt sienna, 3 parts Chinese white and a touch of gold ochre. Mix this with 6 parts water to 1 part colour. Apply the colour with a no. 4 pointed round brush, leaving highlights on the tops of the arms and the left-hand side of the face and neck. (As in all the projects, the light is coming from the top left of the picture.)

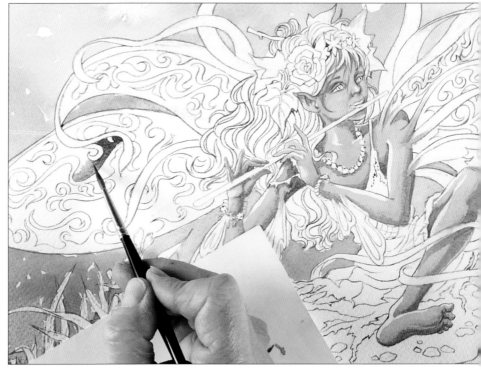

10 Refine the shadows on the face, then clean the brush and soften in the hard edges over the whole of the fairy's body.

11 Mix 2 parts alizarin crimson with 1 part dioxazine violet, then add 3 parts water to 1 part colour. Also use the same yellow mix as you used for the background (1 part gamboge yellow, a drop of Chinese white and 6 parts water) with a little more yellow added to it. Using the no. 4 pointed round, carefully start to drop the red mix into a small section of the left-hand wing, being careful to keep the paint within the drawn shapes. Soften the edge with water as you work.

12 Rinse out the brush, pick up some of the yellow mix and place it next to the red, allowing the two colours to blend on the paper. As before, keep the paint within the drawn pattern. When you have filled a small area, wash the brush again and drop in some more red.

13 Continue in this way, alternating between red and yellow, gradually building up the pattern on the wing.

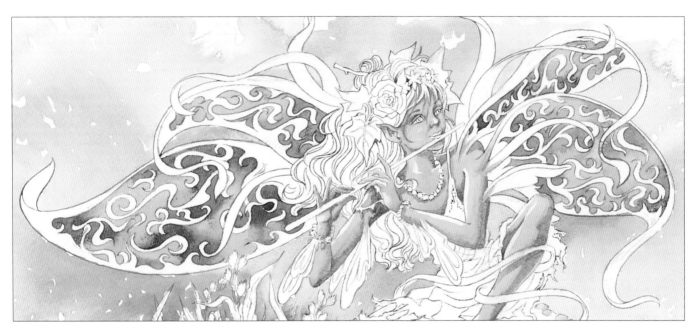

14 Work each wing in the same way, and allow the paint to dry.

15 Turning now to the toadstool, paint masking fluid over each of the spots on the cap and allow it to dry.

16 Mix some cadmium red deep with a touch of dioxazine violet, and add 2 parts water to 1 part colour. Paint this on to the toadstool cap using a no. 4 pointed round brush.

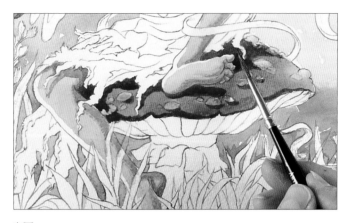

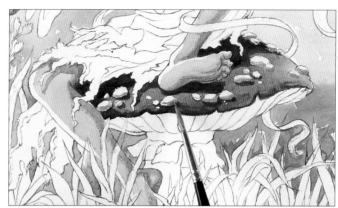

17 For the shadows on the toadstool cap, mix alizarin crimson with dioxazine violet in the ratio 1 : 1, then add 2 parts water to 1 part colour. Paint in the shadows around the edge of the cap and under the fairy's clothes, legs and feet. Soften the edges of the shadows with a clean, damp brush.

18 Allow the paint to dry, then rub off the masking fluid. Using the same brush and a mix of 1 part Payne's gray, 1 part Chinese white and 2 parts water, paint around the lower edges of the spots to give them a raised appearance. Clean up any spots that have been accidentally painted over with a touch of white gouache.

19 Add a touch of dioxazine violet and a little more Payne's gray to the mix, plus a little more water, and model the underside of the toadstool cap and the stalk. Soften the edges with clean water and allow to dry.

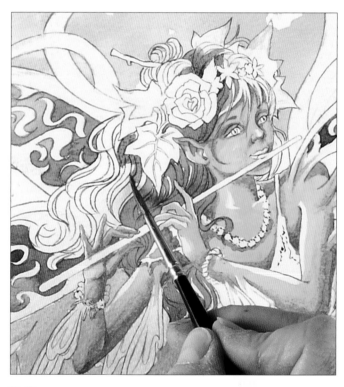

20 For the hair, mix some cadmium red with a touch of dioxazine violet and brush it on, leaving white highlights. Follow the drawn lines with your brushstrokes, working carefully around the flowers and leaves. Allow to dry.

21 Using dioxazine violet mixed with water in the ratio 1 : 1, put in the darker areas of the hair – around the hair adornments and along the right-hand edges of the lower hair sections.

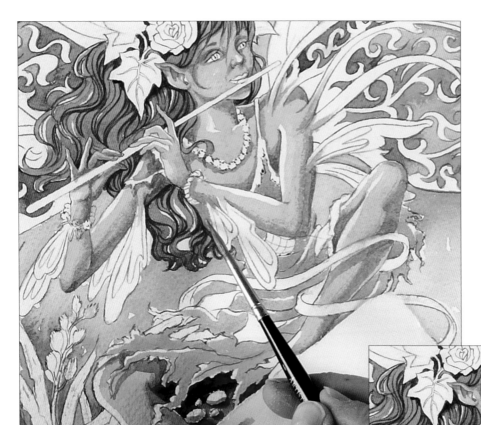

22 Mix 2 parts gamboge yellow with 1 part Chinese white and a tiny touch of alizarin crimson. Add a little water and paint in the dress, leaving white highlights to accentuate the folds and a white border around the hem, neckline and straps. Allow to dry.

23 Add some dioxazine violet to the yellow mix and deepen the shadows within the folds.

24 Look at your painting carefully and complete any missing sections of skin tone. For the darkest shadows lying across the leg under the fabric of the dress, use a fairly thick mix of burnt umber and touch it in using the tip of the brush.

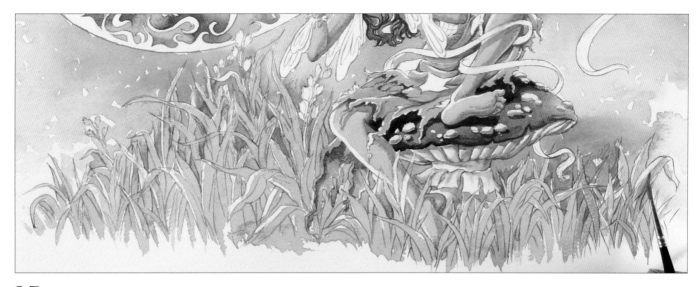

25 Paint loosely over the grasses with a watery mix consisting of 1 part gold ochre and 5 parts water. Use a no. 4 pointed round brush and leave small patches of white for highlights. Allow the paint to dry.

26 Mix 2 parts alizarin crimson, 1 part dioxazine violet and 4 parts water. Paint in the wing tips, leaving a white highlight along the edges facing the light source.

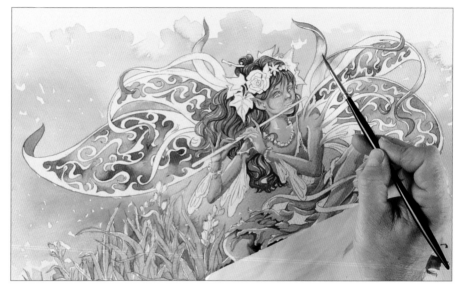

27 Fade out the colour on each wing tip and soften the edge with water.

28 Make a watery mix of 1 part Payne's gray and 2 parts Chinese white, and put in the shadows on the wings to emphasise the curves, folds and overlaps. Soften them in with a clean, damp brush.

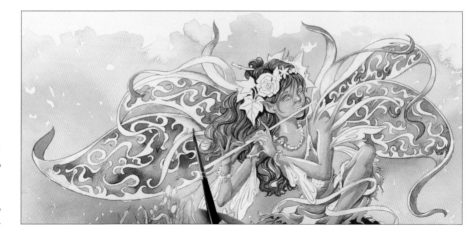

29 Use undiluted gamboge yellow to put in the rose, leaving the white highlights.

30 Add a little burnt umber to the gamboge yellow, and put in the shadows on the rose.

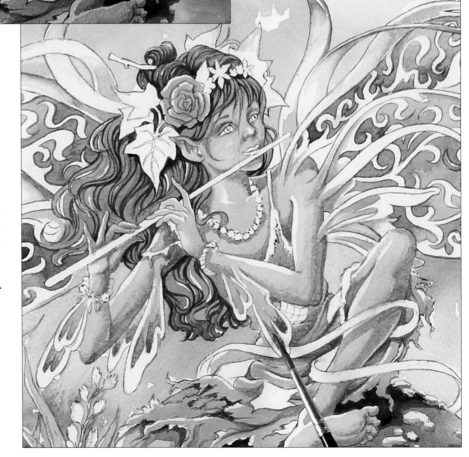

31 For the small wings on the fairy's arms, use the same yellow mix as on the main wings (1 part gamboge yellow, a drop of Chinese white and 6 parts water). Leave a white border around the outside of the wing.

32 Drop in the red mix that you used on the main wings (2 parts alizarin crimson mixed with 1 part dioxazine violet, then with 3 parts water added to 1 part colour) and allow it to blend with the yellow.

33 With a thin mix of 1 part dioxazine violet and 1 part Chinese white, go carefully around the irises of the eyes using a no. 0 brush, leaving a tiny highlight.

34 For the lips, use a tiny amount of cadmium red deep mixed with a tiny touch of Chinese white. Leave a highlight on the upper lip.

35 With ivory black, dot in the pupils leaving a tiny white highlight, and delicately touch in the eyelashes.

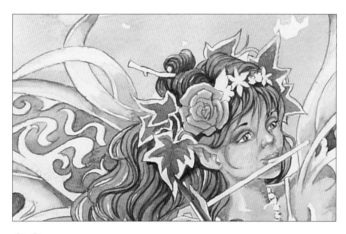

36 Mix a little Indian red with 2 parts water and paint over the leaves in the fairy's hair, leaving a white border.

37 Mix 1 part gamboge yellow with 1 part Chinese white and 1 part water, and lay it loosely in the white border around the leaves. Allow the paint to dry.

38 With the same mixes as those used in steps 36 and 37, paint in the rest of the flowers and leaves in the fairy's hair.

39 Use the yellow mix to colour the flowers and bangles around her wrists, and the necklace.

40 For the ribbon, mix some cadmium red with a little dioxazine violet. Paint it in, leaving white highlights along the edge and on the folds. Soften the highlights with a clean, damp brush. Use the same colour to put in the patches on the fairy's dress. Use the tip of a no. 2 brush.

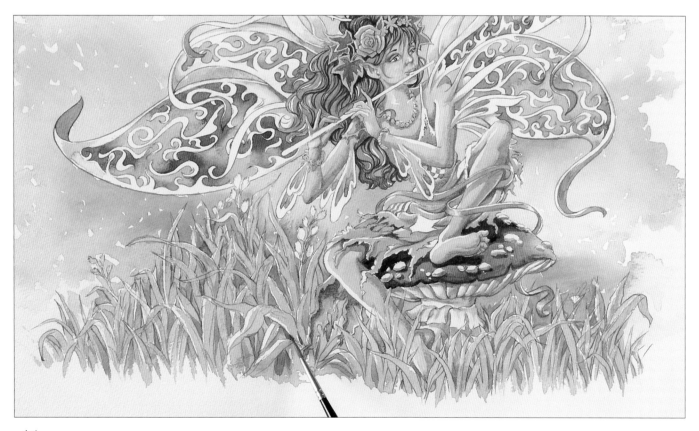

41 Make a mix of 1 part gold ochre, 1 part Indian red and 3 parts water, and loosely lay the colour within the inner recesses of the grasses to give it more depth.

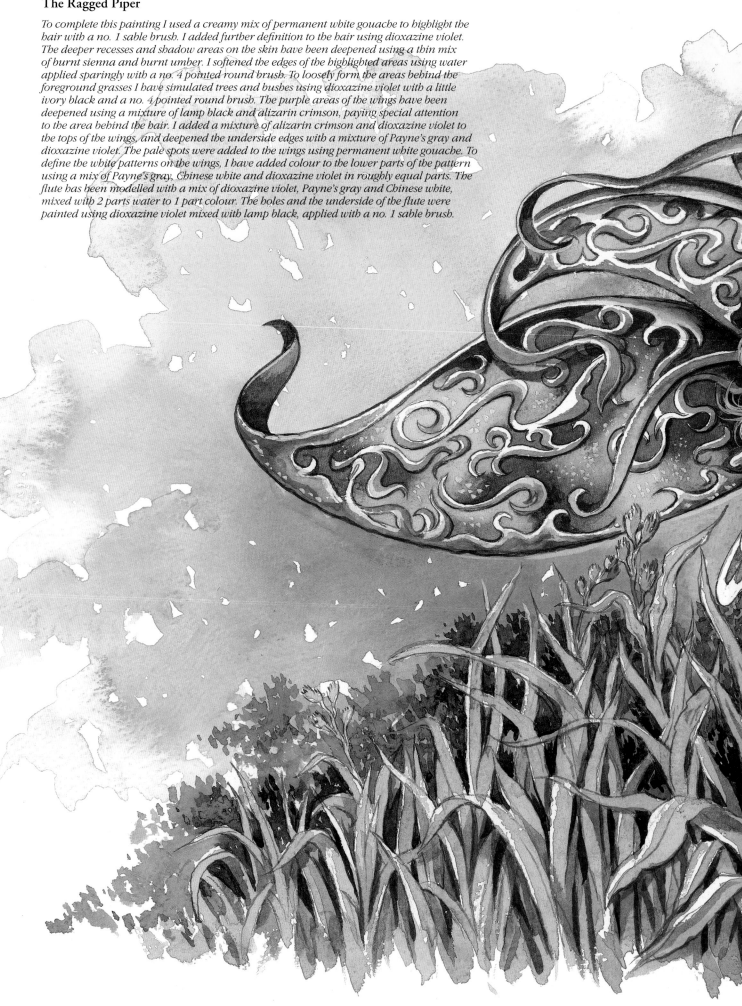

The Ragged Piper

To complete this painting I used a creamy mix of permanent white gouache to highlight the hair with a no. 1 sable brush. I added further definition to the hair using dioxazine violet. The deeper recesses and shadow areas on the skin have been deepened using a thin mix of burnt sienna and burnt umber. I softened the edges of the highlighted areas using water applied sparingly with a no. 4 pointed round brush. To loosely form the areas behind the foreground grasses I have simulated trees and bushes using dioxazine violet with a little ivory black and a no. 4 pointed round brush. The purple areas of the wings have been deepened using a mixture of lamp black and alizarin crimson, paying special attention to the area behind the hair. I added a mixture of alizarin crimson and dioxazine violet to the tops of the wings, and deepened the underside edges with a mixture of Payne's gray and dioxazine violet. The pale spots were added to the wings using permanent white gouache. To define the white patterns on the wings, I have added colour to the lower parts of the pattern using a mix of Payne's gray, Chinese white and dioxazine violet in roughly equal parts. The flute has been modelled with a mix of dioxazine violet, Payne's gray and Chinese white, mixed with 2 parts water to 1 part colour. The holes and the underside of the flute were painted using dioxazine violet mixed with lamp black, applied with a no. 1 sable brush.

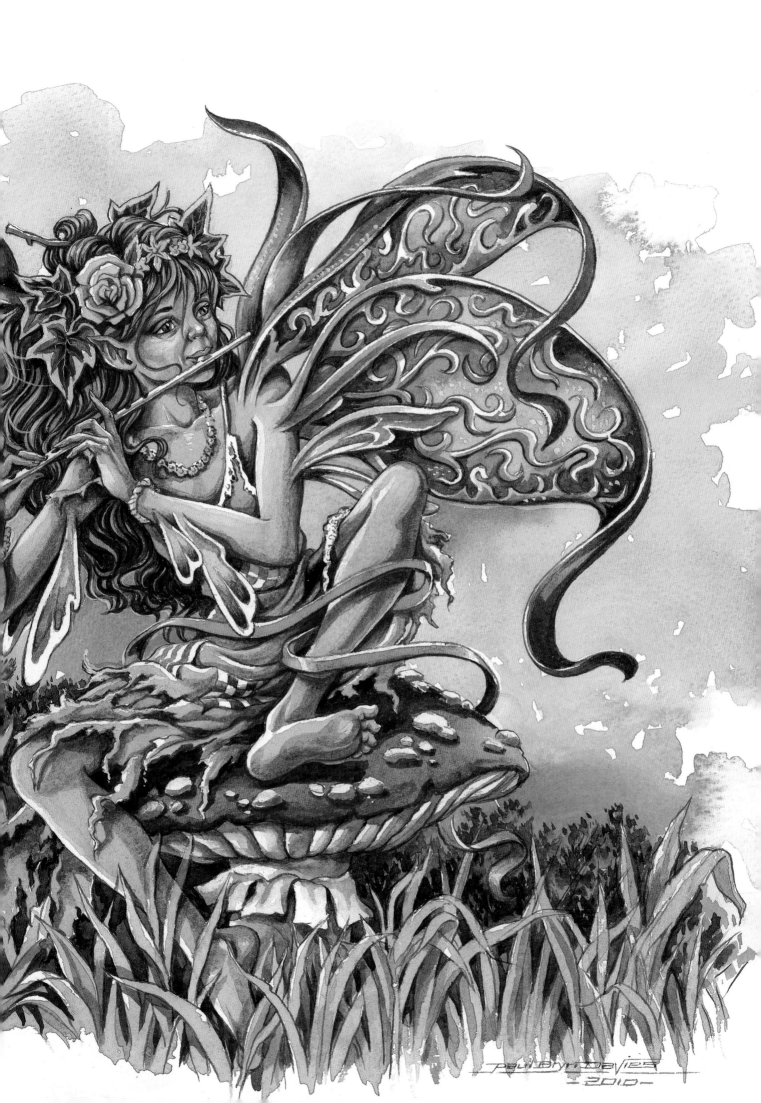

INDEX

Matchbox Girl

In tune with my fascination for deviating from the traditional scene for a fairy painting, what better setting than a rubbish bin? I also like to use this colour scheme in a complex composition in order that the fairy becomes the focal point. Apart from a few coloured stars, the background is deliberately monochromatic. This scene is painted on HP (smooth) 140gsm (70lb) watercolour paper.

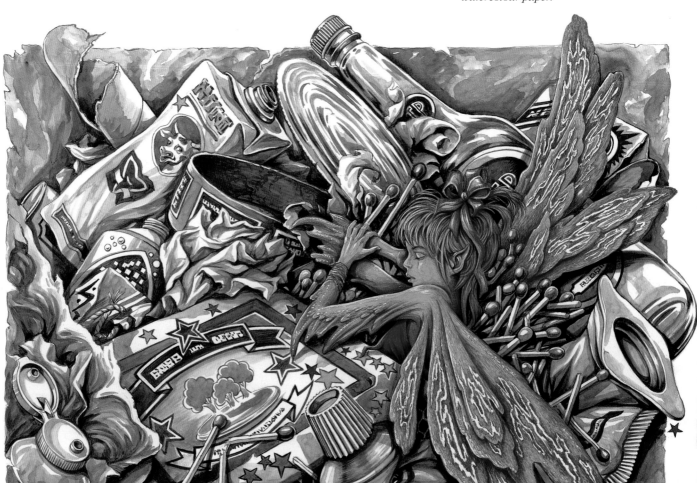